Dedalus Euro Shorts

General Editor: Mike Mitchell

The Staff Room

Dorset Libraries
Withdrawn Stock

D1514210

DORSET COUNTY LIBRARY

204812185 V

Markus Orths

The Staff Room

Translated by Mike Mitchell

DORSET COUNTY COUNCIL

Dedalus

Bertrams 22.08.08

£6.99

Dorset Libraries
Withdrawn Stock

Dedalus was awarded a grant for this book by the Grants for Arts programme of the Arts Council England in August 2007, in March 2008 the Arts Council England stopped funding Dedalus.

LOTTERY FUNDED

Published in the UK by Dedalus Limited,
24–26 St Judith's Lane, Sawtry, Cambs, PE28 5XE
email: info@dedalusbooks.com
www.dedalusbooks.com

ISBN 978 1 903517 55 0

Dedalus is distributed in the USA by SCB Distributors,
15608 South New Century Drive, Gardena, CA 90248
email: info@scbdistributors.com web: www.scbdistributors.com

Dedalus is distributed in Australia by Peribo Pty Ltd.
58 Beaumont Road, Mount Kuring-gai N.S.W. 2080
email: info@peribo.com.au

Dedalus is distributed in Canada by Disticor Direct-Book Division
695, Westney Road South, Suite 14, Ajax, Ontario, LI6 6M9
email: ndalton@disticor.com web, www:disticordirect.com

First published in Germany in 2003 as Lehrerzimmer
First published by Dedalus in 2008

Lehrerzimmer Copyright @ Schöffling & Co Verlagsbuchhandlung Gmbh,
Frankfurt am Main 2003
Translation copyright © Mike Mitchell 2008

The right of Markus Orths to be identified as the author of this work and Mike Mitchell to be identified as the translator of this work have been asserted by them in accordance with the Copyright, Designs and Patents Act, 1988.

Printed in Finland by WS Bookwell
Typeset by RefineCatch Limited, Bungay, Suffolk

This book is sold subject to the condition that it shall not, by way of trade or otherwise, be lent, resold, hired out, or otherwise circulated without the publisher's prior consent in any form of binding or cover other than that in which it is published and without a similar condition including this condition being imposed on the subsequent purchaser.

A C.I.P listing for this book is available on request.

THE AUTHOR

Markus Orths was born in 1969. He studied Philosophy, French and English. A teacher for a while before becoming a full-time writer, Orths' reputation is rapidly rising.

He has won numerous prizes and awards including the Marburg Literary Award and the Moerser Prize.

His second novel, *The Staff Room*, has sold over 200,000 copies in Germany.

THE TRANSLATOR

For many years an academic with a special interest in Austrian literature and culture, Mike Mitchell has been a freelance literary translator since 1995. He is one of Dedalus's editorial directors and is responsible for the Dedalus translation programme.

He has published over fifty translations from German and French, including Gustav Meyrink's five novels and *The Dedalus Book of Austrian Fantasy*.

His translation of Rosendorfer's *Letters Back to Ancient China* won the 1998 Schlegel-Tieck Translation Prize after he had been shortlisted in previous years for his translations of *Stephanie* by Herbert Rosendorfer and *The Golem* by Gustav Meyrink. His translation of *Simplicissimus* was shortlisted for The Weidenfeld Translation Prize in 1999 and *The Other Side* by Alfred Kubin in 2000.

PROLOGUE

I haven't been out of the house for three weeks for fear of missing the call. I've forbidden all my acquaintances to ring me up. Nothing, I told them, could be so important it couldn't wait until after the call. When the phone rang during the first week it was early in the morning and I was still in the shower. I shot out without pulling the shower curtain back, almost slipped and got to the telephone just in time, just before the answerphone cut in. The only word I could make out was *survey* and I slammed the receiver back on the hook. I sat on the sofa, quivering with agitation, naked and dripping wet. From then on I abstained from my morning shower. I asked a neighbour to go out and buy me a cordless telephone. I unplugged the old telephone and plugged the new one in at four o'clock in the morning, a time when the probability of a call was close to zero. Then I attached a string to the receiver and tied it round my neck. Nothing can go wrong now, I thought. I had my meals sent in from a restaurant that had a home delivery service. With the telephone round my neck there was no problem opening the door to the delivery boy. Then I sat in my flat and waited. I put the television sound on the lowest still audible setting. I wasn't relaxed enough to read. Every day at four o'clock in the morning I pressed the button to make sure the line was still working; there was no question of going back to sleep until the dialling tone had come. I frequently recalled the horror stories we had heard on the course about people who had been *unobtainable* during the call period. How reckless, how irresponsible towards oneself and one's life! One, they said, had even gone on holiday during that period; another had answered, but since it was ten o'clock on a Saturday evening this person, clearly not in their right mind, had said it was the weekend, they had other things

to do and would the caller please be so good as to ring back on Monday morning. The whole course had burst out in uncontrollable laughter when the Coordinator told us that story. I pictured what would happen if I missed the call: a life spent under the bridges, sleeping in a hostel for the homeless, despair, horror, cold. But all I had to do was clasp the telephone dangling over my chest to find reassurance. I had done the right thing, I was *obtainable*, permanently, at any hour of the day or night, apart from the one second at four o'clock in the morning. I let myself go during those weeks, didn't bother to shave, just splashed a handful of water over my face in the morning, got rings under my eyes because I wasn't sleeping enough, padding round and round the flat instead. And when, after three weeks, the telephone finally did ring, it put me in such a state of shock I couldn't do anything after the first ring. At the second ring I clutched the receiver, only to realise that the string was too short for me to put it to my ear, first of all I had to pull it over my head, like a chain, before I could press the button, and I missed the third ring as well because I got caught up in the string, but then I had the telephone at my ear and croaked, 'Yes?' It was my mother. I was speechless. She was telling me something, but I wasn't taking it in. After a few seconds I interrupted her. Was she mad? I cried. How could she ring me up, now, at twenty past ten in the morning. Did she not know that was when the probability of a call was at its highest? Did she not know this was the call period? A press on the button got rid of her. She had taken twenty seconds. What if the Coordinator had called at the same time as my mother? During those same twenty seconds? What, I asked myself, if he had heard the engaged tone, put the phone down at once and called the next candidate on the list? I cursed myself for having been so slow. I should have rung off straight away, I told myself, at once, the moment I heard my mother speak, I should have pressed the button immediately after she said, 'It's me' in order to free

the telephone, but no, I'd let myself be inveigled into that meaningless communication and lost valuable time. But now I knew what I had to do. I mustn't let myself be taken unawares, I told myself, I must calm down, concentrate. I cut a longer string so I wouldn't have the same difficulty taking it off. And from then on I spent several hours a day meditating in order to be able to receive the call with due calm. As often as possible, I held the telephone in my right hand so as not to waste a second when it rang. I wrote a reminder to myself on a large sheet of paper and placed it on the living-room table. 'Do not answer any calls,' it said, 'apart from the one call.' And it came on 20 August at five forty-five p.m. I was sitting watching the television and I kept calm. In a procedure I had practised for hours on end, I took the receiver from round my neck and gave my name. When I heard the words *Education Head Office*, I slid off the couch and fell to my knees.

1

I went through the underpass: white, scrubbed tiles, drops of water, an old man playing the accordion and singing something about the hills of home. I paused for a moment and dropped a coin in his Tyrolean hat. Then I climbed up to the bridge, crossed the little river called the Fils and went along Johnstrasse: cars, muck, the air scarcely breathable. At the *Spring Dew* restaurant a waiter was putting up sunshades. I turned off to the right: there was the school. I entered the school office and said I wanted to see the headmaster. I had, I added, an appointment for eleven o'clock. The headmaster, I was told, was in a meeting. I waited and looked at the office counter and the photos on the wall: teachers with leads round their necks and, in the foreground, two men, one fat, one tall, holding the leads; on their heads they wore caps with the letters EHO.

Soon afterwards I was called into the headmaster's office. The headmaster pointed to a chair facing him. I sat down. He was, the headmaster said, the man who would write my appraisal. 'What appraisal?' I asked politely. The appraisal at the end of the year, he said, the appraisal at the end of every year, he, the headmaster, he wrote them, himself. The appraisal, he said, would decide my career, for good or ill. It was, he added, preposterous that I did not know what the appraisal meant, the appraisal, he said, was the most important thing for teachers, the appraisal was their sole concern, nothing else was of significance for them. He would keep himself informed about my every step, he added, nothing, he said, would be hidden from him, at the end of the school year it would all be there before him and he regarded it as his duty to draw up an especially detailed picture of new arrivals in particular. I nodded, not moving at all. Why, the headmaster now

asked as he scrutinised me, why did I not live in Göppingen? I said that until that point I had not had the opportunity.

'Not had the opportunity,' he broke in, what did I mean, not had the opportunity, that was unacceptable, I had already been informed two weeks ago that I was to come here, to Göppingen, to the ERG, not had the opportunity, he said, that was not the best of starts. When, he asked, was I thinking of moving?

'As soon as possible,' I said, hastening to add that I entirely agreed that the distance between my place of work and my place of residence was not the most convenient –

'Indeed,' the headmaster broke in, that was beyond doubt, he was adamant that anyone who worked there also had to live there, all his teachers lived in Göppingen, he personally had made sure that all his teachers lived in Göppingen and I would not be able to get out of living in Göppingen either, if I intended to work there, under him. After all, he said, Göppingen was a fine town. Yes, I said, of course I would make every effort to find a flat as soon as humanly possible, in order to erase the black mark I'd earned by not living in Göppingen. *For that*, the headmaster said, it was unfortunately too late, he had already as good as put it in the appraisal, he could already see my appraisal in his mind's eye: when I took up my duties I, Kranich, probationary teacher, had not been in possession of a suitable residence in the town where I worked, what is more, when I took up my duties I, Kranich, probationary teacher, had not been aware of the significance of the headmaster's appraisal.

While he was speaking I tried to give him a submissive look, but it proved impossible, the headmaster was moving his head to and fro too much as he addressed me and when he fell silent he turned his attention to my application form. I had not, he said, indicated any class. What kind of class? I asked. A class for which I would be responsible as class teacher. I had thought, I said, that as a newcomer I should perhaps –

'Out of the question' the headmaster said, precisely because I was a young teacher it was my bounden duty to take over a class. 'A fine way to start,' he said, 'trying to get out of the most difficult task right from the beginning. No class,' he said, writing something on a pad; his pencil broke, he picked up the sharpener, sharpened his pencil, picked up the pad with the shavings on it, took it to the wastepaper bin, swept the shavings into it, blew the bits of lead off the pad, placed the pad beside him, looked at the pad again, read what he'd written, then tore the sheet off and placed it in one of the trays to his left before turning back to me.

He was going to be quite open with me now, he said. After everything that had happened so far, he advised me to stop. Even before I had begun. I should turn back even before I had climbed aboard the teachers' train, go away, seek alternative employment, anything but teaching. Yesterday he had looked at a video of classes I'd given during my teacher training, awful, he said, dreadful, totally useless, an absolute dead loss as a teacher, my question-and-answer technique, he said, beyond belief, no technique at all, the whole lesson with no question-and-answer technique discernible, question-and-answer technique was what distinguished a good teacher, question-and-answer technique was everything. After all, the aim was to get the pupils where you wanted them, to drive them into a corner with questions until all that was left was the correct answer, the *solution*. Only then could one reward the pupil who had been the first to stumble into the trap. Had I never listened to pupils talking after an oral test? All they were trying to do was find out what the teacher *wanted to hear*, all they were trying to do was establish what the *expected solution* was. No, teaching was certainly not a profession he would describe as desirable for me, the headmaster went on. My questions had been far too open, in every respect, that silence, almost a minute, putting a question, waiting a minute, inefficient, pointless, it was plain to see, a person should realise that. The pupils

wanted *clear* questions, they wanted a helping hand, things made easy, they wanted to scrape everything out of the teacher's head that he had poured in during the hours of preparation, they wanted to gobble up everything in the teacher's head so to speak, to read all the prepared, reliable, assured material on the blackboard, write it down in their exercise books, absorb it and take it home with them. He coughed for a while, then calmed down and while he was silent I hastened to assure him that naturally I was prepared to take on a class as class teacher, I had merely overlooked the box that needed ticking and I begged him to give me one more chance. He waved my words away and said, certainly, certainly, I would get my chance, if I insisted, he had simply wanted to be honest with me. After he had blown his nose the headmaster made two crosses in my file, *two* classes, he said, he would give me two classes so that I would see the way the wind was blowing from the very beginning, and I said, certainly, sir, two classes.

2

And now, the headmaster went on, he was going to initiate me into the mysteries of school life, as he always did at a first interview with a new member of staff, he would be brutally frank and tell me, without mincing words, what awaited me. One could, he said, speak of four pillars on which the whole education system rested. These pillars were fear, moaning, pretence and lies. Lies, he said straight away, were something I must take to heart, they were the elixir of the school. Everyone there in the school lied. First and foremost he himself, the headmaster. Nothing of what he said necessarily corresponded to the truth, I could never, he said, be certain that he would keep to anything he had promised. A promise made by him was not a promise in the strict sense of the word, often enough teachers would come on their bended knees to him in his office, pleading, 'But you promised, sir.' But every time that happened he, the headmaster, would ward off the poor teacher grovelling before him with the well-known, not to say notorious saying that promises were meant to be broken, and carry on as if nothing had happened.

The headmaster puffed out his cheeks. Did I follow him? he asked. I nodded. And I could only survive, the headmaster went on, if I followed the system that was standard practice there. Let us say that one morning I did not feel like turning up in class, even though I was physically perfectly able to do so, what would I do then? Naturally I would come, I said. Well done, said the headmaster, I was a quick learner: my first lie. No, he said, I should ring up and say I was unwell. Of course he, at the other end of the line, would know very well that I was not telling the truth. But he had no problem with that. He would see other qualities in the fact that I was not telling the truth. He would see it as a demonstration of willingness, of my

willingness to adapt to the system, my readiness to join in the game. Woe betide me, however, if I were to stick to the truth. The truth was a clear insult, a revolution, a slap in the face for him, the headmaster. He would have to take the strictest measures should he be confronted with the truth. Did I smoke? he then asked me. A quick glance at the desk told me there was no ashtray on it and so I said no. The headmaster sniffed suspiciously and said he could, however, smell smoke. That must have been because the only seat I could find on the train was in a smoking compartment, I said. A non-smoker, then? the headmaster asked. That was good, he had no time for smokers, he hated smokers. Despite that, he had been obliged to set up a smokers' corner, in his school. As was appropriate, he had put it beside the rubbish bins, but no teacher who was a smoker had ever complained about the proximity of the stinking bins. They accepted everything, did the teachers. Yes, the authorities had even gone so far as to introduce regular tortures to find out what these teachers were capable of putting up with. There, in the ERG, the tortures were held every Wednesday, during the sixth period. Each and every one of them was obliged to attend the tortures. The tortures were called staff meetings. Nothing of what he, the headmaster, said during a staff meeting made any sense at all, but nevertheless the teachers were obliged to act as if it did make sense. Those celebrated discussions, for example, which ended up at the very place they had started out from. Headmasters' training courses laid particular stress on the art of leading a round-table discussion. He, the headmaster, had spent a long time honing his technique of leading round-table discussions. The most important rule was basically simple: end = beginning. The discussion had to go round and round the table and end up where it started, leaving the participants no wiser than before. Really the teachers ought to protest and say what they all thought, namely that nothing had changed. But they'd rather die, those teachers, than volunteer their opinion,

all they wanted to do was to get home, to get the round-table discussion over as quickly as possible. Thus eventually one of them would hold up both hands – I should know that some-one who held up both hands did not want to ramble on in the usual pointless manner, no, for that one only had to hold up one hand, anyone holding up both hands was raising a *point of order*, usually around one-thirty p. m. For example:

'One moment ladies and gentlemen, I see two hands, a point of order, is it, Herr Safft, yes?'

Herr Safft: 'Could we vote on whether to conclude the debate?'

If a point of order was raised, one had to break off what one was saying at once, stop the debate in mid-sentence, to hear the point of order. There was no choice, once a point of order had been submitted they had to take that point of order, unless a colleague should raise a further point of order, immediately after the first, to the effect that they should vote on whether to reject the first point of order, which could, of course, lead to a further point of order, and so on. But usually the teachers were jolly glad someone had proposed the so-called guillotine motion, they would even heave sighs of relief, the end of the discussion was in sight, they were delighted to vote, result: 57 for, 12 against.

The headmaster paused to get his breath back, stood up, brushed a speck of dust off a rubber plant and went over to the gallery of portraits of his predecessors. His own likeness was the last in the row and he stood in front of it as if it were a mirror and brushed his hair back off his forehead. Then he sat down again and continued. Staff meetings, he said, were only one of the countless torments Education Head Office had brought in, another was the so-called visitations during which Education Head Office police attended classes given by estab-lished teachers and always criticised precisely the features they observed: if the teacher had included group work in the les-son, the teacher failed to assert his or her personality; if, on the

other hand, the teacher went for 'chalk and talk' instruction, the lesson was too teacher-centred; if the teacher had copied a passage for the lesson, the passage was poorly chosen; if the passage was in the official textbook, it was wrongly used; if the teacher used a transparency, it was brought in at the wrong point; if he wrote on the board, they said why not use the overhead projector? There was no way out, the headmaster said, no escape from the torments of appraisal and arbitrary judgments. And over the years these torments had engendered fear, now the most important pillar of the system, fear hovering over everything, the king of scourges, so to speak, the inner strength of the whole system. He did not mean only the teachers' fear of Education Head Office, of the headmaster, of the pupils, of their parents, he also meant the pupils' fear of the headmaster, of their parents, of their teachers, and the headmaster's fear of the parents and of Education Head Office, as well as Education Head Office's fear of the Ministry officials, the Ministry officials' fear of the Minister of Education, the Minister of Education's fear of the Prime Minister and the Prime Minister's fear of the voters or, rather, non-voters, that is of the parents represented on the School Board: fear was the glue holding everything together. With time fear had become second nature to the teachers and so it had needed an outlet, a safety valve it found in the endless emission of repetitious moans, the third pillar. And the chief moan: how poor the pupils were. They didn't know who de Gaulle was, what Vichy meant, not even what had happened on 1.9.39, they wrote Hitler with two 't's, they didn't know how long the Second World War had lasted, they didn't even know that there had been a *First* World War, one had to be grateful if they didn't spell war *wore*. And then the marking! You sat there, weekend after weekend, Advanced English, a pupil had used an expression you knew perfectly well no native speaker would ever use, your feeling for the language told you that straight away, but no, you could never rely on

17

your feeling for the language alone, you had to rule out every possibility, it wasn't enough just to look it up in Langenscheidt, no, there was nothing in Langenscheidt. In the Oxford, perhaps? No. In Collins? No. So you had to drive to Stuttgart and look it up in the ten-volume Harper's and, indeed, there it was, the expression the pupil had used, archaic, true, but at some point the the 14th century some English-speaking person had once used it, so it couldn't count as a mistake, the most you could do was put a squiggle underneath it.

I should think very carefully, the headmaster said, glancing at the clock and getting up, whether I wanted to join in the endless chorus of teachers' moans. There was no time left, he said, to tell me about the fourth pillar, appearances, that is the fact that everyone who lived and worked there pretended, at the moment he himself was pretending he had no time, if truth be told he had all the time in the world, he said he was expecting a phone call when in fact all he wanted to do was take a nap in his chair, everyone there, he said, pretended, pretended they were good teachers, pretended they were interested pupils. But if everyone pretended all the time then in fact there was no difference between pretence and reality, but that was a tricky philosophical question he would discuss with me another time and if I had no more questions I should pretend I had understood what he had told me and turn up punctually on 15 September with the other four candidates, there, in his office, to take the oath to the State as a civil servant. Then he shook me by the hand, sat down and ignored me. I went out past the secretaries, who gave me friendly nods, almost pitying, it seemed, for the door had been open all the time and they had had no choice but to listen to everything. I went out into the corridor and inhaled, for the first time, the mixture of wood and linoleum, cold concrete, paint, herbal secretions and a little bit of sweat. I walked slowly along the corridor, down the stairs, past the vending machine, out through the glass door, there was the smoker's corner, close to

the silver-grey rubbish bins. Outside the *Spring Dew* were tables and sunshades, with the dust and dirt of the street collecting under them. The waiter, white apron, grey hair, stubble, crooked teeth, tall, placed a dish of roast lamb before the diners at the table I was just passing and said, 'The silence of the lambs.'

3

I got to Göppingen well before the first General Staff Meeting, the so-called school year inaugural meeting, was due to start. I had taken an early train and stood in the station, smoking. I had turned up my jacket collar and looked round now and then. In the underpass I saw the accordion player again. I was surprised he was there so early and, since I had a little time to spare, I spoke to him. He had poor teeth and couldn't speak very clearly, moreover my head was so full of all the things I would be confronted with in the next few hours that I couldn't concentrate sufficiently on what he was saying. I was thinking of my first class with L6b. I had acquired the RAAbits loose-leaf teaching materials and all the current English course books and CDs for the lower sixth year from the different publishers, Klett, Hueber and Cornelsen, and from all this material I had drawn up a detailed programme of work for the semester and had the complete first unit of thirteen class-hours plus optional revision class together with the class test and expected solutions safely tucked away in my file at home. That reassured me, gave me a little of the confidence I needed to survive my first day of teaching. And for my very first class, the most important class in the whole year, the class which, I had been told, would etch itself on the pupils' minds and determine what category of teacher they would classify me as, then and in the future, for this class I had spent a whole weekend slaving away, I had incorporated four changes of approach and specially devised a new lead-in of my own which was a match for any lead-in for a crit lesson. I tossed some money into the accordion man's hat and set off. I had hardly been able to sleep the previous night and I looked somewhat the worse for wear when I examined my reflection in the glass door at the school entrance. Just then a

middle-aged man with a briefcase appeared from the under-ground garage. His face was a bit droopy. He gave me a brief nod and was already past me when he turned round and asked, 'First day of teaching?'

I nodded. We went in together and walked up the stairs side by side. 'Krämer,' he said, 'principal teacher.'

'Kranich,' I said, 'probationer.'

'Seven weeks to go,' he said. I gave him a questioning look, but he just stared with a glazed expression at the next step.

The school office was exactly half way between the headmaster's study and that of his deputy. 'Oh, Herr Kranich,' said the senior secretary, 'a good thing you're so early, you're to go and see the deputy head immediately.'

I knocked. Herr Bassel told me to come in and pointed to a chair. I sat down. 'I've only been in ten minutes,' Bassel wheezed, 'and already the first's rung up to say he can't come in. For a whole week. A cold! As if that were a reason for absence. And how does he know how long his illness's going to last,' Bassel snorted. 'I'll give you one piece of advice, Kranich, right from the start: Stay healthy. And if you should fall ill, drag yourself to school anyway. A sick teacher's better than none at all. Cancelled classes,' said Bassel with a frown. 'Have you any idea how much time I waste here working out the substitute roster? Once,' said Bassel, 'just once in my career as deputy head have I put up a notice on the board which was entirely white, a beautiful, magnificent, shining white, no one off ill, no one on compassionate leave, no one doing some useless, time-consuming, class-cancelling in-service training course, they were all here, all of them, it was 17 October 1991, I can remember it as if it were yesterday, I still have the sheet of paper, it must be around here somewhere, it's just a sheet of white paper with nothing on, never mind, Kranich, I'll show it you another time, we have to get on. What I really wanted to say, Kranich, is the following: without realising it, you yourself are already a victim of these sick so-called teachers. Herr

Beuten's out of action for the next six months, a slipped disc, ridiculous, as if you couldn't teach sitting down, the school's wheelchair-user-friendly. But these doctors have given him a sick note, it's criminal! And Education Head Office sent a temporary replacement with the wrong subject combination. I've had to rearrange the timetable and that means that you, Kranich, have lost L6b. You're to take over 5d instead. That's an honour, by the way, that's the class with the headmaster's son in it and the class with the headmaster's son in it generally gets the very best teachers, of course in your case that remains to be seen, the headmaster doesn't seem to think very highly of you, but no matter, what I want to say is 5d instead of L6b, first lesson today, Klett coursebook, first foreign language, nineteen in the class, only the best, seven have been brought up bilingually, they'll note down every mistake you make, more than two per lesson can have an adverse effect on your appraisal, but that's just by the way, what I want to say is that that should be no problem, year 5 instead of 6, a good class, you should be pleased, Kranich. Any questions? No? Then all the best.'

I asked the secretary about the coursebook for year 5 and she said I should look in the staff library, I nodded and set off for the staff room.

It was to be the only time during that first week that the door to the staff room stood open, a situation that was due to the fact that teachers were tirelessly going into the staff room and just as tirelessly coming out of the staff room. All sorts of cries and shouts could be heard out in the corridor. I closed my eyes for a moment, took a deep breath and was just going in when I ran straight into one of the teachers.

'Oh, good,' he said, drawing me out of the staff room doorway back into the corridor, 'you're one of the new ones, aren't you, have you a moment, Linnemann's the name, there's hardly any photocopying paper, it's beyond belief, the first day of term and no photocopying paper, come on, we'll

have to go down to the cellar, it's very good of you to come with me, what's your name, I can't remember names, you know, but tell me anyway.'

Me: Kranich.

Linnemann: Subjects?

Me: English and German.

Linnemann: Senior school?

Me: Yes, the lower sixth, that is, no, only fifth year, two fifth years, actually English with one of the fifth years now.

Linnemann, flashing his teeth: You really ought to know by now which classes you have, Kranich.

Me: The problem is I've only just –

Linnemann: Which fifth year?

Me: 5d.

Linnemann: Them. Oh dear.

Me: What?

Linnemann: Do you know who's in 5d?

Me: The headmaster's son?

Linnemann: Horst Höllinger.

Me: Horst?

Linnemann: He's done for two of us already.

Arms full of photocopying paper, the two of us went back up the stairs. 'Come on,' Linnemann cried, 'things start in five minutes, we have to hurry.' I went into the staff room with the packs of paper but I couldn't pay any attention to the teachers who were rushing round behind, in front, to either side of me, I just followed Linnemann. 'This way,' he shouted, 'the photocopier's over there.'

'The copier's jammed,' I heard a voice from beside the machine. 'Another three and a half minutes,' someone else cried. A woman spoke to me, 'You must be Herr Kranich, Klüting's my name' – the paper was getting heavier and heavier, I'd lost sight of Linnemann – 'head of department, English,' Frau Klüting said, 'there's a departmental meeting tomorrow, we'll be discussing whether to submit to the Klett

dictatorship for another year or whether to introduce the Cornelsen course at last, that ought to be of interest for you, after all you are an English teacher – '

'What are you doing with all that paper? Sievers, Geography and Sport, this is *my* table, you can't just put – '

'Over here,' I heard Linnemann shout, picked up the paper, nodded to Herr Sievers, said, 'Sorry,' and turned back to Frau Klüting, but just then a teacher stormed up to her, 'Gisela,' he wailed, 'Gisela, if I've told you once, I've told you a hundred times, not 3c, I said, not 3c, anything but 3c and what do I get – 3c.' She was really sorry, Gisela Klüting said, but her hands were – she just had to – when orders came from on high –

'Hey,' someone shouted in my ear, 'have you seen the biology feeding cups, they're usually here in the cupboard?' I shook my head.

'Six twenty-five,' someone beside me bellowed, 'unbelievable, a mother rang me up at six twenty-five, this morning, to excuse her son, bronchitis, six twenty-five, can you imagine, ringing me, *at home*, not the secretary's office, not Bassel, not Höllinger, no, me – '

'That was *last year*,' I heard another voice say, 'before the grading meeting he says to me, upgrade that D to a C, Frau Straub, no way, I say, that's a D, Frau Straub, he says, upgrade it to a C, it's Philipp Schiedle, the son of Heribert Schiedle, he's no worse than a C, I can't re-mark all the class tests, I say, no he says, you can't do that, but his oral performance in class was a clear B, no, I say, it was an E, not a word the whole year, for the last time, he says, change that D to a C – '

'Marxism,' another teacher exclaimed, 'off the curriculum at last, and about time too, get rid of it, all that Marx-Engels tripe – '

' – not my subject,' someone next to me cried, 'who am I, what have I studied – Maths and Physics – and what do I have to teach: Music. It's the same every year but OK, if that's what he wants, I'll go along with it, but there's one thing I can tell

you, there's not going to be any singing, they can work out the surface area of a disc, or use a compass to draw notes, but no singing, I can tell you that.'

I finally pushed my way through to Linnemann and put the paper down on the cupboard by the photocopier. 'Thank you,' said Linnemann.

'*The boss*,' whispered a young woman standing by the wall, a file clasped to her chest. Höllinger came in.

4

In the name of the Minister of Education, the Chairman of the Education Committee and the Director of Education, said Höllinger, he would like to welcome all his colleagues gathered there most warmly to the first general staff meeting of the new school year, which was thereby declared open. As we could see from the agendas, which had been distributed, agenda item one was concerned with the subject of *security*, agenda item two the introduction of new colleagues; agenda item three, on the topic of *creativity*, would be dealt with after the end of normal teaching, that is after period five, at twelve fifteen. Before we became involved in a fruitful exchange of opinion, he went on, he, Höllinger, felt it was his duty to apologise to their new colleagues that there were no desks available for them, but the situation was that an extension to the school was under discussion and as long as the Council had not given the green light, we all had to make do with what little space we had been allocated, a fact which he, Höllinger, deeply regretted, but, after all, he had not built the school and it was not his fault that the headmaster's study was as big as the staff room. The new teachers could fetch a chair from the cellar and sit at the bookshelves in the library, some of which had been cleared of books for that very purpose.

Höllinger paused, looked at the sheet with the agenda items, thought for a moment then leant over to the deputy head. The two exchanged a few words, the deputy nodded and Höllinger said that since they were already on the subject of the new teachers, he had just decided, in consultation with the Core Management Committee, to bring forward agenda item two, which, as those present could see, referred to the introduction of their new colleagues and he asked that this change in the order of the agenda items be noted in the

minutes. To start with Höllinger mentioned the first-year probationers, who were not present because they spent the first weeks of the school year together at the teacher training college, three first-year probationers, he said, two of them women. He extended a warm welcome, he said, to the second-year probationers, above all to Herr Kracht, who was a Göppinger, the genuine article, as Höllinger put it, and he was especially delighted to have his staff enhanced by the addition of a born-and-bred Göppinger, a Göppinger who had not only never left the town and still lived there, only two and a half minutes on foot from the ERG, no, a Göppinger whose Göppingen spirit, whose Göppingen soul one might even say, would also, of that he, Höllinger, was convinced, contribute to a considerable improvement in the atmosphere in the school and even now he, Höllinger, could say that at the end of the school year he would make every effort to keep the Göppinger at the school. When he looked through Herr Kracht's file, he said, he, Höllinger, had to take off his hat to Herr Kracht for his achievements. Kracht had outstanding grades from his first year as a probationary teacher, an excellent appraisal from his previous head, and, as far as he could tell, there was only one blot on Herr Kracht's curriculum vitae. The teachers listened attentively, as Höllinger said that he, Kracht, had attended the wrong high school in Göppingen, that is not the ERG, but the KNOGY. The teachers greeted this with quiet, polite laughter and Höllinger leant back. Then he introduced the other new arrivals. Kranich's grades, he said, were on the poor side, Kranich's appointment was solely due to the fact that there had been regional elections that year and, as usual, extra teaching posts had been approved as a sop to the voters. Beyond that, it looked as if it was the beginning of the end of the good times, during which he, Höllinger, had been sent nothing but graduates with first-class degrees, worse still, it looked as if a time was once more approaching when they would have to make

do with what was available, a staffing crisis, that was what they called it, however, what he wanted to say was that it was not his fault, he could not help it if the quality of their junior colleagues was constantly declining, he could do nothing about it, he had to go along with what Education Head Office decided.

And now, Höllinger went on, he wanted to go back to the item on the agenda that had been postponed, namely *security*, and to remind them of the incident that had occurred during the winter of the previous year when, during break, a pupil had stolen some money from a classroom that had not been locked, which had resulted in a justified complaint from the parents to Education Head Office, as a consequence of which he, Höllinger, had drawn up a directive to the effect that all the rooms in the school were, as was right and proper, to be locked during every break by the teacher who was taking the class in that room immediately preceding the break. From now on that teacher, the directive stated, was to wait until all pupils had left the room and then lock the door, as stipulated. Now he, Höllinger, was going to proceed to a vote to have this directive confirmed by the GSM. If any teacher present had any objection to the directive, which was surely not the case, this was the time to raise it.

'Three against,' Höllinger counted, panting a little, 'Herr Jensen, of course, Frau Berchtold, Herr Renner. Right then.' Höllinger turned back to the assembled staff and said that he saw that the majority had come to the correct decision, it was therefore a staff decision, for which we were from now on jointly responsible, and each and every one of us had to stick by it, only in that way could we, the ERG, maintain a minimum of security, for only if the security of our pupils was guaranteed could we expect trust, could we expect the parents to continue to entrust their children to us, and security could only be guaranteed if we all made certain that such an incident as had occurred the previous year never occurred again.

In order to achieve this, we had to continue to ensure that the precious keys, that were in the teachers' keeping, should be kept in such a way that no unauthorised person could get their hands on them. And in order to check that the teachers did observe this duty of care he had, as he did every year, appointed an SSO, a *Secret Security Officer*. The SSO – he was saying this for their new colleagues – was one of their number whose identity was unknown to anyone apart from him, Höllinger himself. The task of the SSO during the course of the school year was to purloin keys which their colleagues had carelessly left lying on a table or elsewhere. Should the SSO succeed in this, he or she would be moved up the performance review scale by one point for each key they purloined, while the careless teacher, who had allowed him- or herself to be robbed of his or her key, would be downgraded by one point. He, Höllinger, therefore reminded the new teachers above all that it was in their own best interest to make sure they always had their keys with them, if possible tied by a string to one of their trouser belt loops. This would by now have become second nature to the old hands. One should never forget, Höllinger concluded his address, that the most important things in this school were the keys and the teachers' most important responsibilities were key responsibilities.

5

After the staff meeting half the teachers leant back in their chairs, while the other half leapt up, grabbed their briefcases and dashed out of the staff room. They were the class teachers who were in charge of one of the classes in the lower school. Despite what Höllinger had said, I had not been allocated two classes, not even one, for some inexplicable reason I had not been made class teacher of any class at all. So I asked one of the teachers, Bruns, Biology and Chemistry, where the library was. It was directly accessible through a door in the staff room. I walked along the shelves and found, after a certain amount of searching and to my great relief, a rather tattered copy of *Greenline* for the fifth year and was about to return to the staff room, when I was grabbed by a man with a black beard.

'Stop!' he said, 'You can't do that, you can't just take a book, Miller's the name, principal teacher, History and Latin, the library's my responsibility.'

I told him that I wasn't trying to steal the book, that I had a fifth-year class to teach, right now, after class registration, and that I had been told in the school office that I could find a copy of the course book in the staff library. That was quite correct, Miller said, but I could only borrow the book after I had filled in this green lending card.

'Of course,' I said, took the card, filled it in and handed it back to Herr Miller. He shook his head and said he had to stick by the regulations, he could only give me the book if, along with the lending card, I could also show him my staff library card, the number of which he absolutely had to enter on the green lending card. Where could I get this staff library card? I asked. In the school office, he said. I left the staff room, went to the senior secretary and told her I needed a staff

library card for the staff library. No problem, she told me, she would get one made and I could pick it up the next day. But I needed it *right away*, I said. Calm down, calm down, the senior secretary said, it took time, all the checking, printing, gluing and laminating, she couldn't do that before the next day, couldn't I see how hectic things were just now?

I left the school office and, unsure how to proceed, sat down on the blue sofa in a corner of the staff room. Beside me was one of the three who had voted against Höllinger's directive at the GSM, Herr Jensen. How were things? he asked. I looked at him, horrified. Fine, I said. What was my first impression of the school? he asked. Fine, I said. But then I pulled myself together and told him about the situation regarding the English course book. No problem, he said, stood up, went to his desk, rummaged round in his black briefcase, came back with a copy of *Greenline* and handed it to me, saying, 'My name's Josef, by the way.'

'Martin,' I said, feeling the corners of my mouth lift a little. I could keep the book until the next day, Josef said, he was going to start the parallel class with a song by Britney Spears.

'By Britney Spears?' I asked.

'The kids love her,' Josef said, 'they're really crazy about her.' Didn't I know that the first class was the most important of all, the one that decided how the whole school year would be, so for that reason he didn't want to start with the dry course-book rubbish. Of course not, I said, my head dropping. Then I plucked up my courage and said there was a question I wanted to ask about the headmaster, I didn't know who to ask, but he, Josef seemed to me. . .

Josef put his hand on my arm and looked round. 'Not here,' he whispered. He knew, he said, he knew what I was going to say, he knew about the *List*. That evening at eight, he said, the Ratskeller in Stuttgart, the back room, we could speak freely there. Then someone called his name from the door. Josef got up, nodded to me and left the staff room.

I had no time to reflect on what Josef had said, since I suddenly remembered I still had to collect my school key from the janitor. Outside his cubby hole was a long queue of probationers and other new colleagues. The janitor had a loud, squawky voice, and various keys were set out in front of him and he pointed to the keys as he repeated the same words to every member of staff: 'Key C6 for all GF rooms, 1G, 2G, 3G, key C5 for Physics lower ground floor LGF4, key C4 for Geography LGF5, key C3 for Biology and Chemistry LGF3 and LGF 2, key C2 for Information Technology LGF1, key C1 master key only for the headmaster, deputy head and cleaners, key D1 for sports halls 1 and 2, key E1 for music room 4G. Do you teach any of those subjects? No? Then key C6 for you, 10,000 euros if you lose it, since all the locks will have to be changed apart from Physics, Geography, Science, Information Technology, Music, Sports, therefore it's recommended you take out key insurance in the school office,15 euros per school year, next please.'

I went to the office, took out key insurance, returned to the staff room, picked up the *Greenline* course book, that was still on the table by the sofa, and was about to start preparing my first class, but there was an oldish teacher sitting next to me, legs crossed, quiet, calm, relaxed, he had a newspaper open on his knees but appeared not to be reading it. He glanced at me, gave a curt nod and said, 'My God.'

'Sorry?' I asked.

'You're so young,' he said. I coughed. 'Brinkmann,' he said, 'Maths and Physics.'

I said, 'Kranich, English and German.'

He said, 'You have it all to look forward to.'

'What?' I asked.

'Everything,' he said, 'your whole career, I have only one year left, my last year.' As he said that he looked right through me, a slightly radiant expression on his face. 'My last school year,' he went on, 'the very last, then I'll have made it, retire-

ment, it'll all be behind me, can you imagine, just one more year?'

Me: 'And then?'

He gave me a quizzical look: 'What do you mean, and then?'

Me: 'Yes: and then?'

He: 'Oh, and then.'

The bell rang, he folded his newspaper, nodded and went out.

6

It took me the whole of break to find the room where form 5d and Horst Höllinger were awaiting me. Fortunately I had suspected that might be the case and had set off in good time, so that I arrived at the closed door of room 203, quickly opened the book and whizzed through the first page, trying to separate the various types of exercise and to work out which exercises would be suitable for which phases of the lesson, then I briefly shut my eyes, snapped the book shut, coughed to clear the pressure from my bronchial tubes, grasped the door-handle and went in.

Forty-five minutes later I was going back down the corridor heading for the staff room. I could feel the sticky sweat under my armpits, I was panting, but everything was subordinate to the relief at having got through my first lesson. Next on the agenda was form 4a, I was well prepared and looking forward to calmly waiting for the second bell when someone came up to me. Out of sheer exuberance, I said, 'I know you, don't I? Herr Linnemann?'

'Correct,' said Linnemann, 'what was you name?

'Kranich, English and German.'

'That's right,' said Linnemann, 'that's who you are. Tell me, haven't you got 4a now?'

'Yes,' I said.

'Well then,' said Linnemann, 'that means you're in room 303?'

'Yes.'

'Now that's one of the two rooms with a video machine and I wanted to watch a video with my lower sixth today, first day of the year, they don't feel like doing any work anyway, what do you think, could we swap, I mean rooms?'

'No problem,' I replied, 'which room do you normally have?'

'Lower ground floor, LGF4,' Linnemann said.

'Fine,' I said, 'then I'll just take my class straight there.'

'Thank you,' Linnemann said, walking off.

I was trying to eavesdrop on two women who were standing next to me talking when Kracht, the second-year probationer from Göppingen came up to me and said, 'Great group of guys, aren't they?'

'Yes,' I said. '

'Fantastic head,' he said.

'You could say that,' I said.

'Great atmosphere,' he said.

'Yes,' I said.

'Do I know where the projectors are kept?' he asked me.

'No,' I said, 'no idea.'

'I do,' he said. 'The media store, in the basement. Heiner Stramm's in charge, that's him sitting over there.'

'Oh really?' I said.

'See you soon,' he said.

The second bell rang, so I went up to the third floor, entered the classroom and told the pupils we'd have to change rooms because of the video machine. 'We goin' to see a film?' the pupils shouted. 'No,' I said, 'not us, the other class.' I asked one pupil if he knew where LGF4 was, he nodded and I said he should lead the way. By now everything was quiet on the stairs, the classes were in their rooms, only Linnemann's lower sixth passed us, 'We're going to watch the beginning of *Pulp Fiction*,' they shouted to my pupils, 'Great,' they called back, 'we'll come too.'

'No,' I said, and ushered the pupils along in front of me down to the lower ground floor where, when I reached LGF4, I found that my C6 key wouldn't go into the keyhole. I looked at the sign outside LGF4, it was the Physics room, so only the C5 key would fit. I told the pupils to be quiet and ran up to the school office. Some teachers were hanging about round the desk, I pushed my way through and asked the

assistant secretary for the C5 key. What kind of key was C5? the secretary asked, she'd lost track ages ago. The physics room, I said. No, she said, she didn't have a key to the physics room. How could I get into the Physics room? I asked. Why did I want to get into the Physics room anyway? she asked. Herr Linnemann and I, I said, had swapped rooms. . . Then why didn't I ask Herr Linnemann? I stared at her, she looked pleased with herself for having thought of it, I nodded and left the office, ran up to the third floor, knocked, heard the introductory sequence to *Pulp Fiction*, heard laughter, knocked again, no response, I went in, pitch dark, 'Herr Linnemann,' I called out, 'Yes,' Linnemann shouted back. 'I need your key,' I shouted, 'Which key?' Linnemann shouted. 'The key to the Physics room,' I shouted. 'Oh yes,' he said, 'come over here.' 'Where?' I asked, 'Over here,' he said, 'the back row.'

I groped my way through the darkness, found Linnemann, took the key from him, set off back and was already at the door when Linnemann called out, 'But you must bring the key back, Kranich.'

I stopped. 'When?' I shouted.

'Immediately you've opened the door down there, you heard what the boss said, after all you could be the Secret Security Officer.'

'Don't worry,' I said, 'I'll return it.'

Back on the lower ground floor, sweating slightly, I fumbled to get the key in the keyhole of LGF4 only to discover that the door wasn't locked and the room was already occupied. It was Herr Bruns with one of the middle-school classes.

'What are *you* doing here?' he snapped. I told him I'd swapped rooms with Herr Linnemann and Linnemann had said that according to the timetable he should be teaching here, in this room, now, so that the room, LGF4, ought to be empty since Linnemann was up on the third floor.

'That's right,' said Bruns, explaining that he'd left his own room on the ground floor because the noise from the

rebuilding work going on around the entrance was unbearable. But if I wanted, he said, he'd go back to GF3.

'No, no,' I said, 'you stay here, that's too much upheaval, I'll go.' So I closed the door and told the pupils they were to go up to GF3, I'd be back right away, I just had to go away again briefly; one of them asked me if he could have a smoke while I was finding the right room. I ignored his question, flew up the stairs to the third floor, opened the door and called out for Linnemann.

'Yes?'

'Your key,' I shouted and, now more familiar with the layout, felt my way through the darkness.

'Thanks,' said Linnemann. I ran down to the ground floor, my class were waiting outside GF3, which was still locked. I opened the door, they went in and just as I was about to close the door behind me, a siren sounded. 'Fire alarm,' one of the pupils yawned, walking past me out of the room. 'They do it on the first day every year,' said another. I asked the next what I was supposed to do. 'Close the windows and make sure you take the class register with you,' he said, 'the rest can burn.'

7

Since I didn't have a class during the fifth period, I took the material I'd prepared for photocopying and copied my way through a mountain of paper, breathing in the chemical exhalations of the photocopier, annoyed that I'd forgotten to bring the mask I'd bought during my first year as a probationer. I hadn't quite finished when the bell sounded again and Höllinger came into the staff room, greeting the teachers who were trickling in with a brief nod. When they were all there, he opened the second part of the staff meeting by announcing that he intended to summarise the results of the headmasters' conference that had taken place towards the end of the previous school year. Among other things discussed had been the findings of an international survey. According to this, German schools were not, as had so far been usual, at the top of the rankings, but in the lower regions. As one reason for this regrettable situation the aforementioned survey had identified the fact that German schools were far too achievement-oriented. It had been agreed at the headmasters' conference to do everything to extricate German schools from their present crisis and return them to their former glory, at the top of the league. In order to facilitate this return to the company of the best, they had agreed to accept unconditionally the revised guidelines of the Federal Council of Ministers of Education regarding the increased emphasis on creativity in the classroom and put them into effect. The reason for this measure was German schoolchildren's inability to work independently, which had been criticised in the international survey. To this end we, the teachers, were strongly urged to read the new volume on teaching methods that had just appeared in the series *Teaching Practice* with the title: *Aids for Teachers in Guiding Pupils towards the Independent*

Production of all Kinds of Creative Work and to incorporate it in our lessons. The volume described in cross-curricular terms what creativity was, what conditions were necessary for the release of creativity, what brain functions were responsible for an acceleration of the creative processes and how all that could be prepared, implemented, guided and reviewed supportively.

However, said Höllinger after a brief pause, fierce discussion had broken out regarding an important question. There had been intense argument on the subject of the *assessment* of CPAs, creatively produced assignments. The primary focus of the debate had been the question of *how* to implement the assessment of creativity; there had also been discussion as to how far the assessment of CPAs would be open to legal challenge. Parents, it was pointed out, had demonstrated often enough that they would not hesitate to go to their lawyers. At the least glimpse of the possibility of any kind of legal challenge, it was said, parents would immediately assert their right to protect their children from having to repeat a year or getting catastrophic results in the school-leaving certificate. If creativity, it was argued, were to be accorded such a large share, a disproportionately large share one might say, of school work – in comparison with the objectively measurable transmission of knowledge – then it had to be accompanied by a system which guaranteed absolutely that the assessment of CPAs was not open to legal challenge. That meant that each individual secondary school had to draw up a detailed catalogue which set out the *criteria* for the assessment of CPAs point by point. To this end the headmasters' conference had passed a formal resolution that each school had to establish a commission for the establishment of creativity assessment criteria, in short CECAC, which was to address the task of establishing creativity assessment criteria with immediate effect. Only in that way could a thread of order be woven into the chaos threatened by the unbridled

spread of creativity, only in that way would we be immune to any legal challenge, only in that way could we help the pupils to find out what we, the teachers, expected of them, the pupils.

8

As I sat in the midday train, emptiness flooded my mind, I slumped in the seat, whacked, and let the train carry me off. At the terminus in Stuttgart I got out like an automaton and took the underground. I bought a kebab from the stall on the corner and sat at my kitchen table in my coat, eating listlessly, chewing, biting off a chunk, chewing, then threw away the last oily hunk of bread, cleaned my teeth, lay down on the bed and slept for three whole hours. I'd forgotten to set the alarm and woke at five. In panic I immediately sat down at my desk, where I was relieved to find that I had only three classes to take the next day, two of which, 4a and 1a, I'd already prepared, leaving only 5d. I drew up the lesson plan in minute detail. I took the headmaster's criticism to heart and thought about what question I would be asking the pupils at what minute in the lesson, what possible answers the pupils might give and how I could react to these answers with apparent spontaneity. I thought, too, about what associations the text might trigger off in the pupils and how these associations might turn into vocabulary questions in the pupils' minds, questions they might put to me, not because they were interested in the word they were asking about, but to test me out, my knowledge and therefore my general competence as a teacher. *Murmeln* – 'marbles' – was one of the words that cropped up in the text to be translated. *Murmeln*, I thought, from that the pupils might ask about *Murmeltier*, which I knew was 'marmot', then about sleeping through the winter, which I had to look up: 'hibernation'; from hibernation they could get to lack of food, I looked up lack of food and food supply, then hoard, but from hibernation, I thought, they might go straight to winter and from winter to winter sports, to skiing and bobsleigh racing. I had to look up *Lawinengefahr* – risk of

41

avalanches – and that led on to things like being buried alive, St Bernards, my list was growing and growing. Finally at half past seven I felt I was sufficiently equipped to deal with any imponderables that might emerge during the lesson and pushed my notes to one side. I briefly shut my eyes, imagining one of the pupils asking me the English for *Lawinengefahr* and me nonchalantly firing back the answer without hesitation and, as I packed my briefcase, I was wondering how to manoeuvre the pupils from the marbles in the text to the risk of avalanches if, contrary to expectation, they didn't bring it up themselves, but then I looked at the clock and thought, the Ratskeller, if you set off now you'll be there in nice time.

In the back room of the Ratskeller, heavy curtains over the windows, smoke in the air, three teachers were sitting at a table. I stood in the doorway for a moment, looking at them; they hadn't seen me yet. I recognised Josef Jensen and I suddenly had the feeling I was doing something forbidden, I turned round, felt the urge to go away or to look behind the curtains to see whether there was anyone there who had it in for me. By that time, however, Josef Jensen had seen me. He stood up and waved me over. 'D'Artagnan,' he called out. I went over to the table. Now, in the light of the unshaded bulb, I recognised one of the other two teachers. It was the other man, short and stocky with grey stubble, who had voted against Höllinger's directive at the GSM. I racked my brains for his name. 'Herr Renner?' I asked. He nodded, 'Achim Renner, Sport, Geography and Psychology.' The third was introduced as Pascal, though that wasn't his real name, they said, but everyone at the school called him that, Religion and Philosophy, he was at least six feet tall and his voice was a scarcely audible falsetto purr. After a beer had been brought for me, the three raised their glasses and smacked them together over the table. I joined in and Achim said, 'All for one and one for all.' We drank.

It turned out that the three of them were the hard core of the so-called CG, the *Conspiratorial Group*, which had the aim of undermining the current school system. But *not really*, as they hastened to assure me, since they wouldn't seriously want to put their own jobs at risk, but merely, as they put it, verbally. A group of revolutionaries, then, who did nothing, just talked about what they'd like to do and about the true state our corrupted, thoroughly decrepit school system was in. I asked Josef why, as a new teacher, I, Martin Kranich, had immediately been admitted to the group and Josef said that it wasn't they, the group, who decided who belonged to it, but the headmaster. The headmaster? I asked. There was a List, Josef said, on which Höllinger now and then placed this or that teacher, for a variety of reasons: one didn't live in Göppingen, another had black hair, the third was a woman and the fourth had studied the wrong subject. The List was in the bottom drawer of Höllinger's desk. Everyone knew about it. But only a few had actually ever seen the List. However he, Josef, got on well with the cleaner. And she'd told him that Höllinger had put me, Martin Kranich, on the List, right from the start, even before my first interview.

'Me?' I asked.

'Yes, you,' he said.

'But why?' I cried.

'Why?' said Pascal, musing.

'Why?' said Josef Jensen, raising his glass again. They all took a drink and fell silent.

'We're drowning.' Pascal's whisper suddenly filled the silence. 'Men, women, individuals, human beings, we're being swallowed up, eaten up, gobbled up, gummed up with conflict and competition, humanity, what makes a human being a human being, the heart, the heart's understanding, none of that's in any of their educational strategies, what's real, what's important, what's essential is being ripped out of our innermost being. We're going to mutate into machines, into

monsters, our own misbegotten progeny, if we don't make a mighty effort to resist the mechanisms of these machinations. The guiding principles of an institution of learning should be kindness and cooperation, warmth and understanding, away with this playing at sheriffs, with this control, with stoking up the pressure to perform, we must create an atmosphere for the pupils in which fear is absent, an atmosphere in which they can first and foremost have an opportunity to find themselves.'

Hierarchies, Achim Renner broke in, were certainly not what people generally. . . moreover creativity ought to be. . . on Bali, for example, that was what he was getting at, they had a quite different way of looking at mankind – rootbound thinking, here in the West, that was quite the opposite, so to speak, to their way of thinking on Bali, it wasn't widespread at all on Bali, on the contrary a person's name changed with the birth of their children, so to speak, unlike here, and one could say that it ought to be somehow possible to break up hierarchies and allow a constructive chaos to develop from the very first, so as not to stay stuck with this rootbound thinking, whereas on Bali. . . chaos, to put it in a nutshell, was from the very first the source of creativity.

Could he perhaps repeat that about rootbound thinking? I asked, but Pascal started up again: 'Sincerity, authenticity, coming from within, standing by what you want, not letting them keep you down, not going along with them, making full use of your pedagogical freedom, ignoring the syllabus, doing your own thing again, getting in touch with your inner self, clearing out the rubbish tip of useless knowledge that clutters up your head, opening the pupils up to genuine experience, getting them to hear the voice within themselves, giving expression – in the final analysis it's all about self-expression – giving expression to states of mind, revealing and questioning, questioning your own self and the other self: Who am I? Who is the other self? Where am I going? Where is the other self

going? What am I doing here? What is the other self doing here?'

And now all three of them were recounting numerous examples of things that went against their most deeply held ideals, situations which made them suffer and were gradually sapping the life out of them, and we drank one beer after another and the more the three of them talked, the more vehemently I took part in the discussion, the more unreservedly I let myself go, until eventually I completely dominated the conversation and suddenly started describing my initial interview with the headmaster in an unstoppable torrent of words so that the others fell silent and listened closely so as not to miss a word. Then there was silence. Renner ordered another round. I was already starting to think I'd made a mistake, I'd stuck my neck out too far, I was already about to say it wasn't that bad, the staff were nice, all things considered I'd been lucky to get sent to that school, when Achim Renner spoke. The headmaster was right, he said. How did he mean? I asked. All this 'as-if', he said. We, the hard core of the CG, were only pretending we wanted to change things, we were too firmly rooted in what the hierarchies provided in this space without chaos, whilst on Bali –

'Yes,' Josef broke in, 'that's right.' And a gleam suddenly appeared in his eye. For a moment I thought he'd had too much to drink, but he got up, briefly steadied himself on the table then stood there, without swaying, and said, in solemn tones, that today, here and now, the time had come to proceed to action.

Pascal and Renner stared up at Jensen and said, 'What's this you're on about, stop it, sit back down.'

'No,' said Josef Jensen. Now, as a foursome with our new ally at our side, here, today, he was going to make a solemn vow –

'That's enough,' said Renner, 'we're not on Bali – '

– a solemn vow, Josef said, that henceforth he intended to

let the power of words lead to deeds, that henceforth he refused to stand idly by while everything we said died away, unrealised, in the back room of the Stuttgart Ratskeller, that henceforth he intended to take up the fight and challenge the system in all its diabolical forms. Then he sat down and looked at each of us in turn. For a brief moment Pascal and Renner were silent. Then Achim said, 'You can't do that.'

'Well,' said Josef, taking a sip of beer, 'I'm not going to start throwing bombs.'

'But?' I asked.

'A campaign of little pinpricks,' said Josef Jensen.

What was that supposed to mean? Pascal asked.

'You'll see,' said Josef as the waitress came in and said wearily that it was five o'clock and she wanted to go home.

We got up and staggered out. Is the underground still running at this time? I asked. No idea, Renner said, but it was too late for him to go to bed anyway, he knew a café nearby that was already open where we could prepare for the coming day at school over three pots of coffee. A good idea, said Pascal, and I went along too, though with the uneasy feeling that I'd forgotten something. I only realised what it was at half past six when we were sitting in the train, listless and still stinking of alcohol. 'My case,' I said.

'What case?' Renner asked.

'My school briefcase,' I said.

'What about it?' Pascal asked.

'What d'you mean, what about it?' I asked back.

'Why do you need a briefcase?' he asked.

'In it,' I said, 'is all the stuff I've prepared.'

Pascal waved my concern aside. He, said Pascal, had never prepared a lesson in his life, he relied entirely on his own intuition. Preparation, he said, was the death of spontaneity. If he were to prepare a lesson, he couldn't be truly and wholly himself, couldn't get close to the pupils. Philosophy and Religion, as he understood them, were only possible on

condition that one approached the pupils *un*condition-
ally, that one engaged with the pupils *un*reservedly, without
any pre-structured thoughts. The best diagram, he said, was
one that developed in the course of a spontaneous discussion,
one that turned out to be completely off-beam at the end of
the lesson, so that one could wipe it off the board with no
feelings of guilt at all. The wrong track, said Pascal, was the
true path that led to philosophy, it was only on the wrong
track that people learnt how to walk and, moreover, how to
decide which direction was the real one to take. He, Pascal
went on, regularly began each lesson by asking the pupils
what was going on inside them, what concerned them, where
they were standing, where he could pick them up, what was
exciting them deep down inside, and starting out from the
pupils' answers he developed the lesson from the immanence
of the *ad hoc* moment.

I objected that this technique was hardly likely to work for
teaching foreign languages. Achim Renner yawned and said,
'The threshold method.'

'What?' I asked.

'The threshold method,' Renner repeated, 'the most
important skill of any teacher.'

'What is that?' I asked.

'Preparing the lesson,' said Renner, 'in the moment during
which you cross the threshold into the classroom.'

'Oh,' I said, 'but I haven't got any books with me.'

'You can borrow them,' said Renner. 'From the library.'

I looked across at Josef, who raised his eyebrows and
shrugged his shoulders.

9

The first thing I did when I got to the school was to go to the toilet and wash my face and the back of my neck. To dry myself I had to operate an automatic, self-ingesting towel dispenser. That morning, at seven fifteen and still befuddled with alcohol, I suddenly had a moment of the most perfect clarity. In a blinding flash I was struck by the realisation that whenever I had used such a machine previously, I had always had to get rid of a used portion of towel *first of all*, and *only then*, in a second operation, had I been able to dry my hands on the clean portion I had pulled down myself. Now however, on that morning at fifteen minutes past seven, it suddenly occurred to me that it was exceedingly involved and completely incomprehensible that one had *first* to pull a new piece of towel out of the dispenser with one's wet, dripping hands and only dry them *afterwards*. It would make much more sense, I thought, if there were already a clean portion of towel ready, so that one could *first of all* dry one's hands and *only after that* pull out a new portion, so that a clean towel was there for the next user. When I went through the calculations, I found that in both cases, no matter whether one first pulled out the towel and then dried one's hands or first dried one's hands and then pulled out the towel, in both cases one had to dry one's hands once and pull out the towel once. The only difference was in the order of the two operations. All at once I understood the base, disgusting nature of mankind. So low have they sunk that they simply leave the used towel to receive the next hand-washer with a damp and crumpled stare. My heart beat faster as, with a gesture that turned my world upside down that morning, I gave the towel a second tug, so that a pure, clean, innocuous portion of towel awaited the next user of the washbasin. Thus inspired, I left the toilet and went to the

library, where I sat down at one of the shelves that had been cleared and tried to recapitulate the things I had prepared the previous evening. Pascal and I both had the first period free and he helped me by borrowing the coursebooks I needed from the staff library on his staff card.

After the first lesson I took that morning, with 1a, the pupils rushed out past me for the break and I, according to regulations, locked the door, not without having first made sure I hadn't locked one of the pupils in by mistake. I went up the stairs and in the corridor leading to the staff room I ran into Frau Klüting, who spoke to me, asking what my opinion was.

'My opinion? On what?'

'Which coursebook,' she said, '*G2000* or *Greenline*, Cornelsen or Klett, you know, this afternoon, departmental meeting, immediately after the staff photograph.'

'Oh yes, that,' I said, 'I'm for *G2000*, of course.'

'Excellent,' said Frau Klüting. 'And your reasons?'

At that moment Höllinger came out of the staff room into the middle of the corridor, about ten feet from us. 'Herr Kleible,' he called out, bringing a teacher who was hurrying past us to a halt.

'Yes?' Kleible asked.

Frau Klüting and I stayed out in the corridor discussing the advantages of the *G2000* course. Since, however, we were both concentrating more on the conversation between Höllinger and Kleible that was going on right beside us, our own conversation rather suffered and the arguments we put to each other gradually became a means of extending our stay in the corridor. Whilst at first we had pointed out the strengths of the Cornelsen course in a businesslike and professional manner, its better texts, exercises and pictures, eventually neither of us could think of any more advantages and I suddenly said that the colour of the title pictures was more attractive – exactly, Frau Klüting broke in, and the cover was stronger, not

so fragile – correct, I agreed, and it was easier to get the plastic cover round the cardboard, I added – yes, said Frau Klüting, and Cornelsen's reps were much friendlier than those dry sticks from Klett – precisely, I said, and the print was a tad blacker than the black in *Greenline* – true, said Frau Klüting, and the fount seemed somehow rounder than Klett's – yes, I nodded, and the *th* was definitely more authentic, more readable somehow. At that moment the conversation between Höllinger and Kleible came to an abrupt end so that Klüting and I, slightly embarrassed, could also part.

'Right then, see you at twelve,' said Frau Klüting.

'See you then,' I said.

The headmaster had caught Kleible in the corridor and opened the dialogue by asking whether he, Kleible, knew what time it was? Kleible had remained calm and replied that yes, he knew exactly what time it was, if he looked at his watch he could see that it was just twenty-four minutes past nine. In the same tone the head had further asked whether he, Kleible, knew what in general was happening in that school at nine twenty-four? Kleible had replied in an entirely serious and matter-of-fact tone that he knew that very well, the break had started four minutes previously. Correct, Höllinger had exclaimed triumphantly, and did he, Kleible, know what day it was? Kleible had gone along with this and said that was an easy question, it was Tuesday, he knew that because the previous day had been the first day back at school. Good, the head had said, obviously enjoying himself, and then asked whether he, Kleible, knew who during this school year had been allocated the task of playground supervision on Tuesdays? Kleible, with an expression that suggested he was enjoying himself too, coolly said that of course he knew that, he, Kleible himself, had been allocated playground supervision, every Tuesday during break, he had noted it down in his diary, underlined and in capital letters, and not just once, Kleible declared, but on every single Tuesday page in his red teacher's diary from

the savings bank. Höllinger hadn't expected that and stood there, speechless, for a moment, but then he said that if he, Kleible, was so aware of that, then why was he still standing around there in the corridor, instead of being out in the playground, as was his bounden duty. He, Kleible, Höllinger had said, was supposed to be supervising the playground *in the very first minutes* of the break, that was important because experience showed that it was in those very first minutes, when the pupils rushed out rejoicing, that most accidents happened. Kleible had remained calm and invited the headmaster to tell him how he, Kleible, had to arrange things so that he was *the first* in the playground, to supervise the pupils, and at the same time *the last* to leave the classroom in order, as had been agreed at the GSM the previous day, to lock the door after the pupils had left. Höllinger had had no answer to that. Kleible had turned round and calmly walked out into the playground, while Höllinger had retreated to his office.

During that same break the staff room Tannoy suddenly crackled and Höllinger's voice sounded. 'Linnemann,' it said, 'the headmaster's office. At once.' Linnemann went pale, everyone looked at him. Linnemann suddenly clutched his throat and started to empty out his pockets, rummage round wildly in the papers on his desk and look under the table. 'My key,' he gasped breathlessly. Those next to him feverishly helped him look for his key, but they couldn't find it. Shoulders drooping, he trudged out of the staff room. The bell rang, the teachers dispersed to their classes. After the lesson I met Linnemann, who now had his key on a chain round his neck and looked somewhat exhausted.

'Everything all right?' I asked.

He gave me a foul look. 'Was that *you*?' he asked.

'Me?' I said. 'What makes you say that? I gave you back your key, don't you remember, yesterday, room 303.'

'It was dark in there,' Linnemann said, 'how should I know what key you gave me.'

'Herr Linnemann,' I cried, 'no, you mustn't think that, Linnemann, I would never betray a colleague to the headmaster, just between ourselves I have to say the headmaster – '

'Martin,' Josef Jensen, who was standing by the next desk, broke in, 'would you just come with me, please?'

I made my excuses to Linnemann and left the staff room with Jensen, he took me down the corridor, looked round when we reached the end and quickly, when there was no one there to see, pushed me into the gent's. He opened all the cubicle doors, looked round to check, ran his hands over the edges of the cubicles and the projecting wall, felt under the washbasin, knelt down, placed his ear to the floor and listened for a few seconds then stood up and finally whispered that this was the only place where it was relatively safe to talk. He took a deep breath and said slowly, emphasising every word, 'Never say anything against the headmaster in the staff room. You never know who's sitting there. Everything you say in the staff room eventually gets back to Höllinger. He has a sophisticated system of agents and double agents among the staff. So take care,' said Josef, 'and keep your eyes open.' Then he said I should wait a minute before following him back to the staff room and left me there. I leant back wearily against the radiator and stared into space. Abruptly I turned to face the towel dispenser. A used portion of towel was staring at me from under the white box, a revoltingly soggy grin on its face.

10

I got back to the staff room in time for the bell and was greeted by Linnemann with a broad grin across his face. 'Kranich,' he said, 'you're to go to the head after the next period, it just came over the Tannoy.'

With a horrified start I felt my trouser pocket and was relieved to find that my key was still there. I looked round. Josef and Achim had already left. Pascal was still sitting on the sofa. I sat down for a moment and asked him whether he had any idea why Höllinger should have summoned me. He shrugged his shoulders, staring blankly into space. What was wrong? I asked him.

'Inspection,' he said.

'What?' I asked. 'Now? On the second day back at school? From Education Head Office?'

He shook his head. 'A canon,' he said. 'The Church. My *licence* is at stake.'

'Your licence?' I asked.

It was his licence to teach Religion. Some parents had complained about him and his R.I. lessons. He did too little Bible. And now the canon. Checking up. It had just been announced. Period 6. He'd no idea what to do. I looked at him. He sat there, on the sofa, pale and quivering. If his licence to teach was withdrawn, what should he do then? Never again, he said, would he say or do anything against the sacred school system. He deeply regretted his awful rebellious fits. Without the Church licence he was nothing, he said. It was the licence which made him what he really was, a whole human being, the finished article, a human being with work and money to live on. Pascal had got more and more worked up and by the end he was literally clutching onto me. Now he was staring at me with wild, flickering eyes.

I had to go, I said, I was five minutes late already as it was. I tore myself away, grabbed my book and ran to the class-room. I was so confused that concentration was impossible. How could I help Pascal? I wondered. And what did the head want from me? Also for the first time that day I was hit by a great tiredness, I could tell I hadn't slept a wink the previous night and I was trying to take the lesson on auto-pilot. The pupils of 5d who had been brought up bilingually lost count of my mistakes as they shook their heads and tried to write them down. When I failed to use a gerund after *avoid* one of them bit his tongue, another sucked in the air through his teeth, a third gave a groan of pain and dropped his pen, as if it had burnt his fingers. I only brightened up when one of the pupils asked what the English for *Lawinengefahr* was, *Lawinengefahr*, I said, strutting up and down in front of the class, nothing easier, I said, *Lawinenge-fahr*, was a word that none of the English teachers on the staff were likely to know offhand, which showed them, the pupils, how fortunate they were to have been given me as a teacher, *Lawinengefahr*, I said, and swallowed, one moment, I said, I can see it, I said, it's on the tip of my tongue, just a moment, it's coming. The pupils gave me encouraging looks. It's there, I said, I knew yesterday, definitely, you have to believe me, I beg you. 'Well then?' one of the bilingual pupils asked. I slumped, deflated, I had to pass on it. It had slipped out of my mind at some point between one beer and the next in the Ratskeller.

'That too,' muttered Horst Höllinger, making a note. Once the class was over I rushed out of the room, not forgetting first to enter my initials and the usual note on the material dealt with during the lesson in the class register. I walked past Pas-cal, who was still sitting motionless on the sofa, patted him on the shoulder and told him to stay calm. As soon as I'd been to see the headmaster, I said, I'd come back and help him. Then I went over to the staff-room mirror, brushed back my hair,

adjusted my collar, gave my face a rub and myself a few gentle, encouraging slaps and set off.

In the office my voice quavered as I said I had to see Herr Höllinger. The senior secretary gave me a pitying look. As I passed the assistant secretary briefly placed her hand on my shoulder, 'Chin up,' she said. I went to the door and knocked softly. I heard Höllinger's 'Yes?' opened the door and went in.

'Come in, come in, my dear Kranich,' he said. 'Do sit down, would you like a coffee?'

I thanked him but refused.

'Why so nervous?' he asked. 'Are you afraid?'

'No,' I said, 'no, no.'

'Tell me,' said the head, sniffing suspiciously, 'have you been drinking?'

'No,' I said, 'no, why?'

He just had the feeling, drinking during working hours, I knew what that meant, of course. No, I repeated, I was completely sober. Weeks ago, said Höllinger, he'd asked Education Head Office whether it wouldn't be possible to have a supply of those little tubes the police use when checking car drivers. With them he could deal with teachers who'd been drinking once and for all. Unfortunately his request hadn't been acted upon so far.

'I have nothing to hide,' I said, 'you can believe me, Herr Höllinger.'

'No residual alcohol?' he asked.

'No, why do you ask?' I said.

'Because you were seen yesterday,' he said.

'Me?' I asked. 'Where was that?'

'In Stuttgart,' said Höllinger, 'leaving the Ratskeller, around five in the morning, drunk, together with three other conspiratorial characters from the school.'

I went pale. 'But that must. . .' I stammered. 'Where had he. . . no way should he. . .'

'Calm down, calm down,' said Höllinger. It was OK. I'd

lied to him, as per regulations. That was all he had wanted. He was perfectly happy with me. Did I not remember my first interview, the four pillars of the school system? The way I had maintained the façade had been exemplary, through it I had shown myself to be a worthy teacher and wouldn't get into trouble. For what would have happened, he said, if I had admitted everything? The steps he, Höllinger, would have had to take didn't bear thinking about. Did they? I nodded. Be that as it may, said Höllinger, rummaging around for paper and pen, it was time for the usual routine check on my general school-awareness. I gave him a questioning look. He wanted to see, Höllinger said, whether during my first two days at school – for this purpose two days were entirely sufficient – whether during my first two days at school I had managed, as was required, to familiarise myself sufficiently with all the files and noticeboards in his school which were essential for the day-to-day functioning of every teacher. So, could I tell him where the substitute roster was, the announcements of the staff council, the list of the form teachers, the list of mentors for the senior pupils, the classwork programme, not only where the class test programme was, but in what colour class tests were to be entered on the programme, in contrast to the colours for surprise oral tests, for ones of which notice was given and for checks on written homework, furthermore, he said, he wanted to know where the blue folders were kept in which the individual marks for class tests were to be entered immediately after the tests had been marked, in order to make them available to every teacher who taught the class, he wanted to know where the Education and Science Union notices and those of the Association of Language Teachers were to be found, where the decisions of the Parents' Council were kept, copies of the Education Act, the list of approved formulations for writing reports for the lower school, where the booking chart for the two video rooms was, the list of topics proposed for in-service days, where the membership

lists of the class committees and the subject groups were posted for the teachers involved to initial, where the minutes of the most recent meetings of the School Board and the Town Council, the register of employees' addresses were deposited, where the ring binder with each teacher's time-table was. . . Höllinger continued questioning me for several minutes and I could answer most questions to his satisfaction. He had spread out a list on the table in front of him and a satisfactory answer earned me a tick plus a nod of approval, ignorance a dash. Then he leant back and I heaved a sigh of relief, assuming the test was over.

He briefly counted up, then said, three dashes, that was perfectly respectable, although he'd kept the most important question for the end. I sucked up what little moisture was left in my mouth and looked at him expectantly. He asked me where the filing cabinets with the *pupils' marks from previous years* were. I remained silent. Did I know that? No, I said. Höllinger shook his head. These young teachers, he said, they came to his school and thought they could start with a clean slate. Thought they didn't need to bother with what had gone before them. I, Kranich, said Höllinger, was only a tiny elem-ent in the larger scheme of things. The orchestra had started to play long before I arrived. I should be glad that I was allowed to take a seat and contribute a note to its success now and then. Pupils' previous marks, he said, were the backbone of every new beginner and I, Kranich, didn't even know where the filing cabinets with the previous marks were. How did I expect to find out how good or bad my pupils were. If I was unaware of their previous marks, I might come to quite different assessments from my predecessor. Deviations, said Höllinger, deviations were only allowed to a limited degree, as laid down in regulations. In effect, he said, the pupils' grades in the school-leaving exam were already determined in the first year of secondary school. You only had to look at the statistics. Any child who completed the first year with an average grade

of A- would pass the school-leaving exam with something around A-.

'I require you,' said Höllinger, 'to come and see me during the sixth period tomorrow and demonstrate, to my satisfaction, your knowledge of your pupils' previous marks. Copy out the files and learn them off by heart. It is in your own interest. It will help you avoid making mistakes in assessing pupils, and if you make no mistakes in assessing pupils, no parents will try to get at you and you'll save yourself a great deal of legal unpleasantness.'

I nodded and tried to make a mental note of everything. Then Höllinger made what seemed to me like a significant and weighty pause. That was a real boob I'd made, Höllinger said, not knowing where the marks for previous years were kept. But he was willing to turn a blind eye to my oversight, provided – at this point he shifted a little closer to me over his desk – provided, he said, I was willing to oblige him in return. Of course, I said, relieved, willingly, anything he wanted. He remained silent for a moment, seemed not quite to have made up his mind, but then he shook himself, unlocked a drawer in his desk, took out a document and said it was his intention to make me his second Secret Security Officer for that year. He looked at me. I slumped like a house of cards. So far he had always chosen only one teacher for that task, he said, but for a long time now he had been working on a plan to unleash a second SSO on the staff. Were I to accept, he would not mention all the lapses I had already committed at this early point in the school year. He would forget them. Behave as if my performance had been impeccable. That ought to be sufficient as a quid pro quo, he said, if one remembered what I already had on my record: excessive drinking, wrong place of residence, ignorance of previous years' marks. But, Höllinger went on, if I should manage to lay my hands on *two teachers' keys* by the autumn break, he was willing to go so far as to cross me off the List, I did know about the List, of course,

didn't I? I didn't know whether to nod or shake my head so I made an indeterminate gesture. So, Höllinger concluded, did I accept his offer? He looked at me as he spoke. I nodded mechanically. At that he handed me a document in which, as he put it, he certified that I, Martin Kranich, was acting as SSO during the current school year. I was to carry the document on me at all times, as justification and authorisation of my secret role should a teacher catch me carrying out my official duty, stealing keys. With that he stood up and shook my hand, beaming. I gave a feeble smile and headed for the door. I already had my hand on the knob when Höllinger said, 'Oh, Kranich?'

'Yes?' I asked quietly.

'By the way,' Höllinger said, '*Lawinengefahr* is "risk of avalanches".'

11

As I was leaving the school office, one of the secretaries slipped a laminated card into my hand and said, in a comforting tone of voice, 'Your staff ID.' I gave her a nod, but everything around me seemed strangely blurred. I didn't know whether to confide in anyone and, if so, whom, but I decided to keep quiet about it for the moment and see what I could do to help Pascal. Going along the corridor to the staff room, however, I noticed how much the interview with Höllinger had churned up my stomach and turned off into the toilets. I was alone in there. I let my trousers down and lowered myself onto the seat. In order to take my mind off what had just happened, I thought about one of Renner's theories that he had told us about in the Ratskeller the previous evening. From the hierarchical thinking of the western world in contrast to the Balian outlook, he had got onto a fundamental difference between men and women. On the lavatory women, Renner had said, only pulled their trousers down to just above the knee, whilst men let them down to their ankles. As I sat there I was a living demonstration of his theory and I had just reached the point at which the relaxation of the bowels would have led to an opening of the sphincter when it was the toilet door that opened and someone came in. Everything inside me clenched. I listened intently, but heard neither the gush of urine in one of the urinals nor the door of the neighbouring cubicle being opened and closed. The man who had come in was standing in the middle of the gents doing nothing. Was he listening to me? I tried to think whether what I was about to do contravened some internal regulation or other, but could find nothing to object to in my behaviour. Finally the cubicle door next to mine did open, someone locked it, panting and wheezing, dropped his trousers to his ankles, I could tell from

the sound, and sat down on the lavatory seat. It was Bassel, I thought, fat and breathing heavily and emitting peculiar groaning noises. For myself, I found it impossible to concentrate on my own intended task and abandoned it temporarily, quietly stood up and pulled up my trousers. Suddenly I heard a clatter. His key, I thought. I went down on my knees and peered through the gap at the bottom into the neighbouring cubicle. His key was on the lavatory floor. Somehow, however, I felt it was too good to be true, such an opportunity so shortly after my discussion with Höllinger. There was something fishy about it. I pictured Bassel, sitting on the lavatory, cleaver at the ready, just waiting for me to slip my hand through the gap towards the keys dropped there as a lure. No, I behaved as if I had completed the purpose of my visit, pulled the chain, opened the door and quickly headed for the exit, but as I was leaving I heard Bassel's voice from behind the cubicle door: 'Not even washed your hands, Kranich.'

I hurried back to the staff room. From a long way off I could see Josef Jensen coming down the corridor towards me. There was a triumphant smile on his lips and as we passed he whispered to me, 'The bomb's ticking.'

In the staff room I saw that Pascal was still on the sofa with a man in black sitting facing him. The bell rang. Beside Pascal was a basket with burgundy school bibles. Pascal picked up the basket, it was as if he were taking up a cross, and without noticing me he left the staff room, followed by the canon. 'Best of luck,' I said, but he did not respond. So I went to the school office, took the files of all my pupils out of the filing cabinet there and set off for the photocopier. There were six or seven teachers crowding round the photocopier, Kleible in the middle of them holding a tin of toner in hands that were smeared with black. 'OK, OK,' he was saying, trying to calm them down, 'it'll only be a matter of minutes.' I hesitated for a moment, then put on my jacket, left the school, went into town, asked where there was a copy shop, copied my files,

paid, went back and returned the files to the cabinet, being rewarded as I did so with a nod of approval from the head, who happened to be in the office watching the secretaries at work.

12

There were twenty minutes to go before we had to assemble for the obligatory new-school-year photograph outside the west entrance, where the light was best at that time of day. I didn't manage to have a look at the files I'd photocopied because a teacher sat down beside me. She was all in grey, in her mid-fifties, and there was something angular, severe about her movements. She held out her hand to me saying, 'Kniemann, History, Latin, Greek and Ethics.'

'*And* Ethics?' I asked.

'And Ethics,' she said.

I said, 'Kr – ' but she broke in. 'I know,' she said, 'Kranich, English and German.' She, Kniemann, always studied the files of the new staff before they arrived at the school. One had to know *everything*, one should never approach a situation unprepared, especially not as a teacher. For the pupils one was the fount of knowledge. The pupils should be petrified with awe at the authority of the educated mind, at the superiority of the teacher's intellect. Then she looked all round the room and suddenly whispered, shifting up a little closer, 'Herr Kranich, *ask me*.'

'Sorry?' I said.

'Ask me, I beg you, something historical, anything, it doesn't matter what, ask me, come on, get on with it, Kranich.'

I needed a few seconds to order my thoughts and then I stammered. 'OK, right, if you want. When was Rome built, that is, I mean, founded?'

'No!' Kniemann exclaimed, 'Concentrate, Kranich, I mean *questions, real* questions, *difficult* questions, questions no one can know the answer to unless they know *everything*, off you go, get on with it, we haven't got all day.'

I racked my brains and asked her who had been the first foreign minister of the Federal Republic. 'We're not going to get anywhere like that,' she said and took a senior school history book out of her briefcase. 'Off you go, Kranich,' she said, 'open it at any page and ask me.'

I opened the book and asked her how long the Siegfried Line was. 'Yes,' she said, smiling at last, 'yes, Kranich, 400 kilometres,' she closed her eyes, 'roughly 400 kilometres, perhaps more, even more, really called the Western Rampart,' she said, 'built between May 38 and August 39, from Aachen to Basel, around 15,000 bunkers. Carry on, Kranich, keep going, don't stop.'

I asked her about the Concordat of Worms. 'Aha,' said Kniemann, '23 September 1122, between the Holy Roman Emperor Henry V and Pope Calixtus II. Keep going. Josephus Flavius? Too superficial, Kranich, dig deeper, deeper.'

I questioned her for about five minutes, eventually starting to invent questions, Kniemann seemed to know what size shoes Napoleon took, I had no way of checking, what colour the Sun King's hair was (under his wig), what size clothes Lenin and Frederick the Great wore, she knew how many musical instruments Ludwig Erhard could play and at what time of the day the *Marseillaise* was composed. Only when I asked her what strength of lens Franz-Josef Strauss's glasses had did she go pale. Slightly irritated, as it seemed to me, she took the book, stood up and went to her desk. I couldn't tell what she was doing, for at that moment a young teacher in glasses rushed up to me. Was I crazy? she screamed at me. What was wrong? I asked, baffled. How could I have the cheek to wear a black shirt? I couldn't understand what she was on about. Hilde Bräunle, German, French. – Kranich, I said. Er. . . She was the coordinator for the staff photograph, had I not had her letter? What letter? I asked. The letter which explained in words of one syllable what clothes I was to

wear to school that day, Tuesday. No, I said, I hadn't received the letter.

'That's all I needed,' she said and handed me a list. 'There,' she said, 'clearly legible: *Kranich – light top*.' I said I didn't understand. The photographer, she said, could only take the photo if the teachers were in alternate dark and light tops. Because of the contrast. For years she, Hilde Bräunle, had been responsible for sending a letter to the teachers telling them what clothes they had wear for the photograph, not an easy matter to coordinate, since she had to take all sorts of thing into account: some teachers simply refused to wear black, apart from funerals, others had no light-coloured clothes in their wardrobe and as well as that she had to take the teachers' size into account, that is to say who could be placed in which row without blocking out a shorter teacher. She'd spent hours working on the plan. Not to mention sending out all the letters. And now I had the cheek to ruin all her hard work. It was inconceivable that the photographer would release the shutter if there were three teachers in black standing next to each other. I nodded. What could be done about it? I asked. Frau Bräunle composed herself and sat down. Well, she said, as far as she could see there were three possibilities. Either I went to be photographed with my upper body bare. No, I said immediately, out of the question. Or I decided not to be in the photograph. And the third? I asked. We found some teacher, Hilde Bräunle said, who happened to have a spare light-coloured top he could lend me. Fine, I said, I'd ask around.

By that time it was one o'clock and the bell was ringing, so I got up and asked all the male teachers I encountered whether they had a spare light-coloured top; no one could help me, only Achim Renner said he had an idea. He ran off and arrived back just in time with a yellow sports bib, which I put on while I ran to the west entrance before standing there, panting, as I waited for the click of the camera, at the same

time becoming aware that the pressure that had built up in my stomach was now rumbling and gurgling around in my bowels. I recalled the interrupted session in the staff toilets and hoped the photographer would hurry up. It was a full ten minutes before we were dismissed and I dashed off to the lavatory in my yellow bib.

When I came out of the lavatory some time later it was already pretty quiet in the school. I looked for Pascal, but couldn't find him anywhere. He had not even turned up for the photograph. I found that disquieting. Eventually I stowed the pupils' files I had copied in my briefcase, left the school, hurried through the underpass – the accordion-player wasn't there – and went back to Stuttgart. In the train I found a Göppingen daily paper and tore out a few adverts for flats. Back home I ate something or other that was quietly gathering mould in the fridge. While I was eating, I spread my pupils' files out on the kitchen table and started to learn their marks from previous years off by heart. At times I could hardly keep my eyes open, but I forced myself to keep going and by about eight I had the marks firmly fixed in my mind and set about preparing my classes for the next day. I'm going to do it conscientiously, I told myself, and it was two in the morning by the time I finally got up from my desk. I was ready to drop, but I did manage to get out my history book and write down twelve teasing questions and put them in my briefcase so that I would be prepared for any further conversations with Frau Kniemann. As I got undressed I realised I was still wearing the yellow bib. I lay down, snuggled up in the duvet, had a long, relaxed yawn and was just drifting off when a fearful shock had me wide awake again. I sat up and slapped my forehead. The departmental meeting! English! Today! Immediately after the photograph! Completely forgotten! Instead I'd gone to the lavatory, then looked for Pascal and not found him. My heart started to pound and I didn't sleep a wink for the rest of the night.

13

I approached my third day at the ERG completely hung over and tired out. I had spent the night pacing up and down in my flat, wringing my hands as I tried to think what excuse I would give for missing the departmental meeting. I was afraid Frau Klüting would already have reported my absence to the boss. In that case, I thought while I was sitting in the train, everything would be lost, no number of filched keys could save me. That brought my secret assignment back to mind and I started to wonder about opportunities for getting my hands on teachers' keys. Whose key could I steal? And how? Linnemann's? No, he'd had his comeuppance already. Miller's, the librarian's? He was too cautious. Kniemann's? How could you tell?

At the entrance I met Herr Krämer. 'Six weeks and three days to go,' he said wearily.

'Two days,' I said.

'How so?' he asked.

'You're forgetting the third of October, the Day of German Unity,' I said, which Krämer acknowledged with a nod.

The first thing I did when I reached the staff room was to see if Frau Klüting was there, in order, if possible, to keep out of her way. Fortunately she wasn't there. Perhaps she had the first period off. Only then did I notice the odd atmosphere in the room, there was whispering going on all round, an invisible cloud hung over the heads of the teachers, who were passing on information to each other. Renner was beside me. 'The bomb's gone off,' he said, 'they've rung.'

'Who's rung?' I asked.

'The Whites,' he said.

'Who did they ring?' I asked.

'The headmaster,' Renner said. How did he know? I asked.

The secretaries had eavesdropped on the telephone call the previous afternoon, Renner said, later on the cleaner had eavesdropped on the secretaries and passed the information on to him. Then Klüting came in and I felt like crawling under the table but she walked past me with a friendly 'Good morning' and didn't say a word about my absence the previous day. In one way that was a relief, but at the same time it made me uneasy since I didn't know what meaning to put on this overlooking of my absence. I looked round for Pascal but could not see him anywhere. I was beginning to get worried about him.

The bell rang and I had to go to 5d. On my desk the pupils had put one of those little glass spheres filled with liquid that you shake and it starts to snow. I said 'Good morning', shook the glass sphere, admired the sight of the snow slowly falling on the little house and the tiny people inside and said, '*Snow*'. The pupils applauded. In the five-minute break I saw the first abandoned key on one of the teachers' desks and my heart started to beat faster. I couldn't tell whom the key belonged to, looked all round the room and hesitated too long for, with a cry of horror, Bruns, his face red as a beetroot, rushed over and grabbed the key. Then I heard a loud pop and finally saw Pascal, who had just opened a bottle of champagne and, surrounded by six or seven teachers, was pouring it into glasses.

'Pascal,' I shouted, 'what's up?' He handed me a glass, we all clinked glasses and drank. Then one of the teachers gathered up the empty glasses and cleared away all the evidence. Pascal was beaming. He'd got an A, he said. How come? I asked, patting him on the shoulder. He'd given an excellent lesson, he said. Unprepared? I asked. Of course, he said. Excellent, the canon had confirmed that personally. But what had he done then, in the lesson? I asked him. Pascal looked at us, one after the other. To start with, he said, he'd got the children to pray aloud, for ten minutes, all the prayers that he, Pascal, could

vaguely remember, and he'd insisted they were spoken cor-
rectly, Our Father *which art* in Heaven, he'd said, correcting
them, *which art*, who could tell him what we said today? Thy
Kingdom *come,* Thy will *be done, be done*, not *is done*, an old
form of the verb called the subjunctive. Who knew what
hallowed meant? Who knew a synonym for *hallowed*? After
that start he'd got the pupils to take out their Bibles and read
passages from them in turn. For thirty minutes. And that was
it. At the end he'd said a final prayer and asked the canon to
give them his blessing, which he, Pascal, and the whole class
had received on their knees. It was the conclusion to the
lesson in particular that had made a profound impression on
the canon.

Afterwards the canon and Pascal had retired to an empty
classroom in order to review the lesson, but just as the canon
was about to launch into his detailed comments he, Pascal, had
said he bowed to the canon's superior wisdom and didn't
want to waste the coming precious forty-five minutes with
superfluous talk, but would prefer to watch and pray with
him, the canon. The canon had nodded and not only spent
the remaining forty-five minutes praying, but had then
invited Pascal to go with him to St Saviour's, where the two of
them had passed the whole night in silent meditation. To his,
Pascal's, anxious question as to whether his licence to teach
religion would be withdrawn, the canon had replied that no
teacher had ever shown himself more worthy of that mission
than he, Pascal, had. We all clapped. Then the bell went and as
we were setting off for the second period of the day we heard
the head's voice coming from the staff-room loudspeaker. It
sounded cold and void of expression. He said he was sum-
moning all teachers to an unscheduled staff meeting at the
end of the second period. In order to ensure punctual attend-
ance, all staff without exception were to conclude the lesson
that was about to start five minutes earlier than normal. The
teachers went to their classes in silence. Josef overtook me

with willowy steps and I saw him put up his right thumb behind his back.

In order to reach the first-form classroom I had to pass the interview room, the door of which suddenly flew open. I heard a voice: 'Kranich!' In the shadows in the room I recognised Frau Kniemann.

'Yes?' I asked.

'Come in,' said Frau Kniemann. I said I had a class just now. . . She knew that, she said, but she had something important to tell me. I went in and closed the door. Answer-*able*, was the first word she hissed at me. I, Kranich, had committed the worst sin any teacher could commit. Outrageous! Unforgivable! The previous day she, Kniemann, had spent three hours on the telephone. First of all she'd phoned a friend, a political activist who was a member of the CDU. He'd known nothing and had passed her on to a member of the sister party, the CSU, who'd asked all kinds of questions. When he realised that she, Kniemann, was after the optical prescription of the former premier of his beloved Bavaria, he had become most foul-mouthed and abusive. He wasn't having it, he said. Some people kept on trying to sully the memory of the greatest Bavarian statesman of the 20th century. In fury he'd slammed the receiver down. So then she'd had to ring up her CDU friend again, who'd passed her on to three other CSU members one after the other. Two had been unable to help her, so when she rang the third she, Kniemann, had pretended to be an assistant lecturer at the University of Bamberg writing a PhD thesis on *The Significance of the Thought of Franz-Josef Strauss for a Comprehensive Reform of Contemporary Politics* and therefore needed to ask Strauss's daughter a few personal questions. And, said Kniemann, she'd been given the number. She'd rung up Strauss's daughter immediately and asked what strength of lens her father had had. Strauss's daughter had been somewhat amused by the question and wanted to know why she, Kniemann, was inter-

ested in that. Kniemann had explained. In reply Strauss's daughter had said she was sorry but she couldn't answer the question, her father had never worn glasses, his sight had been perfect right to the end. At that she, Kniemann, had said that was not possible, she, Kniemann, had been asked a question, the question had concerned Franz-Josef Strauss's optical prescription, the question had been put by a teacher so there must be an answer to it. Strauss's daughter had assured her it was as she had said and Kniemann had had to ring off without having got anywhere. There was something I, Kranich, should get into my thick skull. Never again, said Kniemann and repeated the words, never again should I ask a question that was *unanswerable*. I must always, Frau Kniemann concluded, etching the word on my forehead, *always* check my questions to make sure they could be answered. A question that could not be answered was not a question, it was a monstrosity, a mockery of the person asked, an impertinence. She wanted to protect my pupils from me and had not been able to wait a second longer to tell me this. I apologised and asked if I could go. When, giving me a black look, she nodded, I asked her if, instead of Strauss's optical prescription, she could tell me something about Charles the Bald. 'Of course Kranich,' she said, her expression brightening a little, 'Charles the Bald, born Frankfurt am Main, 13 July 823, died Avrieux, 6 October 877, fought, in alliance with Louis the German, against Emperor Lothair I.'

I went into the corridor, took the notes I'd written the previous evening out of my briefcase and asked, 'Verdun?'

'Verdun,' said Kniemann, following me, 'treaty of, 843, the West Frankish kingdom.'

By this time I was outside the classroom and put my hand on the door handle. 'Lorraine?' I asked.

'Lorraine,' Kniemann said, 'occupied 869, but Charles the Bald had to share it, with Louis the German. . .'

I heard no more.

14

The interruption had made me ten minutes late for my class, but, by order of the head, I had to end it five minutes early, an order I complied with conscientiously. Then I went to join the other teachers in the staff room and waited. The headmaster came in. Behind him the deputy head, Bassel. Obeying some inner impulse, the teachers all stood up. 'Sit,' said the head. They sat down. I remained standing, with the other new teachers along the wall by the door. Subversive elements, the head began, had established themselves among the staff of this school, elements that he had a mind to tear out by the roots. – 'What did I say?' Renner whispered to me, 'rootbound thinking.' – The previous day he, Höllinger, had received a call from Education Head Office. A reprimand. Never before in his twenty-five years in education, from probationer to headmaster, had he had a reprimand from Education Head Office. Only now, yesterday, for the first time. And the reason? He made a significant pause.

There had been a complaint. The teachers coughed.

From outside, Höllinger said. Silence.

From Frau Doktor Wirtz. Whispering, feet shuffling.

'You all know Frau Doktor Wirtz, you know what kind of person she is,' Höllinger said. 'She complained that I make disparaging remarks about her school at staff meetings.'

The head took a sip of the water Bassel had poured for him and cleared his throat. It had come to the ears of Frau Doktor Wirtz, Höllinger said, that he, Höllinger, had made disrespectful comments about the KNOGY, the *Gymnasium* of which she was headmistress. She had informed Education Head Office that in the first staff meeting of the new school year he, Höllinger, had criticised Kracht, his colleague from Göppingen, for having attended the KNOGY instead of the

ERG, as, in his, Höllinger's, own words, was right and proper for a true Göppinger.

The muttering in the staff room grew louder, people looked at each other, only Josef Jensen sat calmly in his chair, radiating inner content.

'You all know what that means,' said Höllinger. '*We have a mole in the staff.*'

By now the teachers were growing agitated, the first cries were heard: who was it – it was outrageous – whoever it was should own up, at once – the nerve, to tell tales out of school – and to make matters worse, about the head – down with the mole.

The head raised his hand and immediately there was silence. 'A mole,' Höllinger repeated, 'here, among us, among the staff. Someone who reports what is said here, among the staff, to outsiders, and not only to outsiders but to the worst kind of outsider, to the KNOGY.'

Höllinger paused. Then he said he would give the mole precisely seven minutes, starting immediately, to own up. If, after seven minutes had passed, the mole had not owned up, he, Höllinger, would be obliged to set more far-reaching consequences in motion. Silence. The head sat down and stretched out his legs, emphasising how sure he was he would prevail. His eye lit on Josef Jensen but Jensen had no intention of letting the slightest twitch reveal that he – as I was firmly convinced – was the culprit. No, Jensen stretched his legs out as well and leant back so that after a while Höllinger gave him a hard stare. Jensen, a beatific smile on his face, was the picture of innocence. Höllinger looked at me, but only briefly, he didn't seem to consider me a candidate. Scharinger, Kleible, Linnemann, his eye slowly wandered from one teacher's face to the next, but no one confessed. Time passed. Höllinger glanced more and more frequently at his watch, tugged his ear. When the bell rang he went pale, leant over to Bassel, had a brief word with him, nodded and let his eye travel round the

room again. Sounding less confident than before, he said he had therefore decided, in consultation with the Core Management Committee, to cancel classes for the pupils for the rest of the day. The very idea of returning to the regular teaching programme before the mole had been unmasked was unthinkable.

In the meantime Bassel had jumped up and left the staff room. Höllinger said, 'We're going to stay here until the one responsible has owned up.' Then he sat down again. Still no movement among the staff. Bassel returned with a sheaf of papers under his arm which he pinned to the notice board. From where I was standing I could see what was written in bold type on the notices: 1a – cancelled after period 3, 1b – cancelled after period 3, 1c – cancelled after period 3, and so on to the separate option groups for the lower and upper sixth. Höllinger fidgeted restlessly with his pencil. Bassel sat down beside him again, wheezing, and loosened his tie. Time passed. No one moved. They were all quietly staring into space or casting suspicious glances at some colleague or other. After half an hour Höllinger varied his tactics. Perhaps, he said, it was the public confession that was putting the mole off. He, Höllinger, had therefore taken the decision, in consultation with the Core Management Committee – he glanced briefly at Bassel who nodded obsequiously – to interrogate each member of staff individually. For that he would now go to the staff library. We, the teachers, had to come to him singly, in alphabetical order, and that meant all of us. Having said that, he retired to the staff library and closed the door. Bassel photocopied the staff list, took one copy in to Höllinger, stood by the door to the library with the other and called the teachers out one by one. 'Ammel,' he said to start with.

'It wasn't me,' cried Frau Ammel, 'it wasn't me!'

'You have to tell that to the headmaster,' said Bassel, pushing her through the door.

When my turn came I was absolutely sure of my innocence

74

and went into the library. It was completely dark, the head had not only lowered the blinds, he had drawn the curtains as well. I stood there, motionless and asked, 'Where are you?' At that a desk-lamp was switched on, less than two paces in front of me.

'Sit,' Höllinger said.

I sat down.

'There's no point in denying it,' Höllinger said, 'I know everything.'

'What do you know?' I asked into the light.

'It was *you*,' Höllinger said, 'Jensen confessed.'

'Jensen?' I asked.

'Jensen,' Höllinger said, 'made a full statement, he told me everything about the meeting in the Ratskeller, about the CG, come on now, confess.'

'No,' I said, 'I'm innocent, in fact it's Jensen who, who. . .'

'Yes?' Höllinger said eagerly

'. . . who has told you something that's not true,' I said, feeling I'd avoided a trap. Höllinger asked a few more probing questions until he realised he was not going to get anything out of me. Before he dismissed me, he took a piece of paper out of his pocket and said, 'Right then, Kranich, off we go: Bernt Bade, 4a?'

'C,' I said.

'Tina Willems, 5d?'

'B,' I said.

'Alexander Schneider, 3a?'

'D,' I said.

'Höllinger, Horst, 5d?'

'A!' I cried.

15

Outside I had just taken a deep breath when I saw Frau Klüting's eye on me. The interrogation by the head had activated my guilty conscience so that I decided to clear things up. I went over to Frau Klüting and said, 'Frau Klüting, I would like to apologise for my absence at the departmental meeting yesterday.'

'Oh really?' Frau Klüting said.

'I. . . I simply forgot,' I said. It didn't matter, Frau Klüting said mildly, I could forget it, on the contrary, she said, she, actually that was her husband, should thank me for my absence. I had no idea what she was talking about, but I was relieved that I had been spared. I was going to slip away, afraid she might change her mind, but Frau Klüting held me back and said, 'Just a minute, just a minute, don't you want to know which textbook we've chosen?'

'*G2000*, I hope,' I said.

In the secret ballot, Klüting said, all the departmental staff present had naturally voted for Cornelsen's *G2000,* the reasons were plain for all to see. But just as she was about to enter the result of the vote in the minutes, the door had suddenly opened. At this she paused. Someone had come rushing into the departmental conference room, she said.

'Who?' I asked.

'Frogs,' she said, 'five of them.'

'Frogs?' I asked.

'Klett representatives,' Klüting said, 'all in green.'

They had burst in on the meeting and their spokesman had begged the teachers to stay with Klett. No other educational publisher, the Frogs' spokesman had said, laid so much emphasis on *visuality* in their books as Klett. And he didn't need to tell them, the subject specialists, how fundamental

visuality was for teaching. Children, the spokesman had said –
it had started to sound like a lecture – only learnt things when
they were presented to them in concrete, visual terms. A suc-
cessful learning outcome when introducing new vocabulary
was only possible if the unknown word was semanticised by
an object that corresponded to the word or an action that
corresponded to a verb. Verbalisation? the Klett-man said. A
waste of time. Antonyms? Useless. Visuality was the magic
word. Once, years ago, he, the spokesman, had witnessed a
remarkable lesson that had demonstrated his opinion per-
fectly. At that time, the spokesman had said, launching into a
story, he had not been a Frog, he had been employed by the
Whites and one cold January day he had had to examine a
demonstration lesson in English. Oddly enough, the trainee
teacher who was being tested that day did not exhibit the
nervousness his colleagues usually showed, he wasn't pacing
up and down the staff room, pale as a ghost, nor did he almost
collapse when the two examiners, that is he himself, as chair-
man of the examination board at the time, and the trainee's
subject tutor, appeared. The trainee had been quite calmly
sitting there, confident of success, he'd been drinking coffee
and not let the appearance of his examiners disturb him. He'd
stood up shortly before the bell, picked up his briefcase and
calmly gone to the class, followed by the examiners. It had
been a 2nd-year class, the theme for the lesson: violence,
exploration of the semantic field. The lesson had begun very
sluggishly, the trainee had talked about the difficult situation
of trainee teachers in general, the intense competition
between them, then he'd suddenly said that his chances of
getting a position in a school would be considerably
improved, if he could get rid of his rivals. At that, he took a
gun out of his pocket. Immediately he had pupils' attention.
The examinee had gone to the wall cupboard, opened it and
dragged out a fellow trainee teacher, bound and gagged, had
said the word *to kill,* loud and clear, and shot his colleague. His

77

colleague had collapsed, streaming with blood, beside the teacher's desk. The trainee had then let off another shot into the air, in order to quell the pupils' cries of horror. Then there was silence. Just a few of the girls had continued to sob quietly. In the transition phase that followed, the trainee got the pupils to repeat the word *to kill* several times, not forgetting to remind the pupils whose voices were choked with tears that they must speak louder. In the next phase the trainee, following the guidelines, wrote *to kill* on the blackboard since, as they, the subject specialists, would know, in foreign language teaching speaking the word had always to precede reading and writing it. From the word *kill* the trainee had then been able to demonstrate further important words to the children visually simply by pointing to the equivalent that was there in front of them. *Blood, body, bullet*, then *cartridge case, smoke* and *traces of powder*. Following that, he had developed a *mind map* of the pupil's response, getting them to repeat words such as *fear, screams, trauma, tears* and *horror,* subsequently writing them on the board. Trembling, the children had written down the words in their tear-soaked jotters. He, the Frogs' spokesman, and the subject tutor had been mesmerised by the scenario, in their excitement they had completely forgotten to record the examinee's mistakes on the official assessment form, as required. At the end of the lesson the trainee got the class to repeat the word *suicide* and write it on the board, before putting the gun in his mouth and pulling the trigger. For a moment the children had sat there in silence. Then they'd all jumped up, screaming, but before they could rush out of the classroom, the trainee and his colleague had stood up, wiping the tomato ketchup off their faces. The children had sat down, rigid with shock but spellbound, so that the lesson had taken one more marvellous turn leading to the semanticisation of the word *fake*. The schoolchildren who had been present, the leader of the Frogs said, would never, of that he was absolutely sure, would never forget that outstanding example of visuality

in didactic practice. The words *kill, smoke* and *fear* would be branded on the children's brains for ever.

It was a perfect example, he had gone on, of how indispensable visuality was in the semanticisation process. It simply wasn't enough just to scrawl a picture on the blackboard to bring home to the children the meaning of the word *car*. Nor was it enough to bring a Matchbox car along to the class. *Car* was neither a chalk sketch nor a Matchbox car, the meaning of *car* was solely a real, actual vehicle driving along a tarmac road. Ideally, therefore, semanticisation demanded the teacher bring a real, genuine, large-as-life car into the classroom, which, given the spatial constraints, was naturally not practicable. However, the spokesman had said, they could get the children to look out of the window, into the school playground. Before the class they could park the car in the playground so that it would catch the children's eye immediately. And since Klett was well known for its generous provision of all kinds of visual aids, he was now inviting the subject teachers to look out of the window where they, the Frogs, had set out some of the objects occurring in the first units of *Greenline*, life-size and true-to-life. The teachers, Klüting said, had gone over to the window where they had seen a *car*, several *bikes* and *television sets, radios* and other aids to semanticisation. These objects, the head Frog had said, were now theirs, the specialist teachers', in order to enable them bring the highest possible degree of visuality to the teaching of English in the lower school. At that the teachers had applauded vigorously and set about dividing up the things among themselves while she, Klüting, had signed a contract with the Klett representatives guaranteeing that the school would use no other textbooks than the green ones for the next ten years. The Frogs had withdrawn, happy with the result, and the teachers had cracked a bottle of champagne.

Frau Klüting concluded by explaining that I had thus already been sufficiently punished for my absence since the

bicycle that had been intended for me had been given to her husband, who taught English at the KNOGY, a Klett stronghold. It didn't matter, I said, with a sigh of relief, as long as the matter was forgotten. Klüting was shaking her head when I heard someone outside in the corridor kick the staff room door. I went over, opened it and saw a 15-year-old girl who had cupped her hands and was holding something in them, I couldn't tell what. She asked me if I could give *this here* to Frau Hoffner. I nodded and held out my hands; the girl filled them with a pile of dry gobbets of used chewing gum that had obviously been scraped off the pupils' desks, turned round and disappeared. I dumped the chewing gum on Frau Hoffner's desk, telling her that *this here* had been handed in for her.

'Excellent,' Frau Hoffner said, and started to count the gobbets, '12, 14, 16, 18, 20, very good, the first time it was five, the second ten, the third twenty.' Then she looked up at me and said she didn't mess around, there was one simple rule: if you chew, you scrape it off.

16

When the interrogations were finally finished the head came
out of the library, exhaustion written all over his face. He had
put a flower in his buttonhole and sat down, head bowed. His
voice was hoarse. He *begged* the mole, he said, at which every-
one fell silent, he begged the mole to come forward. He,
Höllinger had tried everything. It was one o'clock, he said, we
were all hungry. He promised nothing would happen to the
mole. Here and now, in the GSM, in front of seventy wit-
nesses, he promised the mole that he or she would go
unpunished. No movement among the staff. The head fought
for breath. Swallowing audibly, he went on. What would they
think of him? At Education Head Office? A head who was
incapable of exposing a mole among his staff? An incompe-
tent head, a failure. He, Höllinger, was under strict orders to
report the name of the mole to Education Head Office by
four o'clock that afternoon. Otherwise – he fell silent and
wiped the sweat off the back of his neck with a handkerchief –
otherwise: a committee of enquiry. The teachers all twitched
nervously. And we all knew what the meant, the head went
on. The Whites would come. A comprehensive review of
teaching and administration in the morning, individual inter-
rogations in the afternoon. He, the head, would also be inter-
rogated. So he was repeating his plea. Still no one moved. In
that case, Höllinger said, he had no choice, it would have to be
decided by lot. The teachers were silent for a moment, then
they started to whisper encouragement to each other and dry
their sweaty hands on their trouser legs. Bassel handed the staff
list to one of the second-year probationers, who carefully
laminated it on the machine next to the photocopier, then
Bassel cut the strengthened list into little strips, threw them
one by one into Gräulich's hat – Gräulich wore it whenever

possible to conceal his toupet, since he didn't know that everyone knew it was a toupet. Then Höllinger closed his eyes, picked out a strip, looked round the assembled group and said, 'The mole is. . . Frau Ammel.' We heard a shriek and saw Frau Ammel leap up and fall, rigid with shock, into Hilde Bräunle's arms. The head left the staff room.

After having had lunch with a few colleagues in the *Spring Dew*, I was sitting, lost in thought, in the Stuttgart train with no other desire than to lie down in bed and sleep. I was in an open carriage and paying no attention to the people who walked past in the gangway. When the train stopped in Plochingen one of those getting out dropped a note in my lap which said, in clear letters: *Meeting, Stuttgart Station, 9 p.m.* I turned round and was just in time to see someone dressed entirely in red leaving the carriage and getting off the train. The train started. The man in red was standing, motionless, on the platform with his back to me. I stared at the note, baffled, with no idea what to make of it.

Back home in Stuttgart I went straight to bed. Since four periods had been cancelled, I was more or less already prepared for the next day. I hadn't set the alarm and when I woke up it was dark. I had a shower, smoked three cigarettes and set off at a quarter to nine. In the station underworld I took up a clearly visible position, standing at one of the high tables behind the glass wall of the *Café Marché*. I smoked, rubbed my foot on the leg of the table, picked crumbs off the beige tabletop and subjected every letter of the neon sign advertising *Stuttgarter Hofbräu* to intense scrutiny. When, after some ten minutes, I turned round, the man in the red coat was standing behind me. He was wearing a hat and sunglasses.

'Don't move,' he said, 'don't look at me. There's a black briefcase under your table. After I've gone, wait ten minutes, then pick up the briefcase and go home. You'll find the combination for the lock on the back of the video of *The Grapes of Wrath* in the video library at your school.'

With that he left. I waited ten minutes, uneasy and staring into space, feeling for the briefcase with my foot. I managed to locate it so that when the ten minutes were up, all I had to do was bend down elegantly, without attracting attention, pick up the briefcase and go. 'Hey!' someone shouted as I was leaving. I froze. 'Aren't you going to pay for your coffee?'

17

I couldn't sleep that night. I'd spent a long time examining the briefcase and tried in vain to open it with a nail file and a screwdriver. *The Apartment* with Jack Lemmon was on television at eleven forty-five. Just before the end when, with the words *Especially not Miss Kubelik*, the clerk C. C. Baxter alias Jack Lemmon, refused to give his boss J. D. Sheldrake, played by Fred MacMurray, the key to his apartment, which for years had been used for extramarital affairs, and instead, in a gesture of absolute contempt, tossed the key to the executive washroom on Sheldrake's desk, which resulted in his immediate dismissal and consignment to the employment waste-heap, I felt a lump in my throat. And when, in the final scene, the marvellous Miss Kubelik, played by Shirley MacLaine, left her lover Sheldrake, at midnight, while Auld Lang Syne was being sung, and ran through the cold New Year's night to Baxter and, coming up the stairs, heard a bang from Baxter's apartment and thought he'd shot himself, when she hammered wildly on the door and Baxter, completely nonplussed, opened it holding the bottle of champagne he'd just opened, when Miss Kubelik went into Baxter's apartment, took off her coat, sat down on the sofa beside him, picked up the deck of cards and shuffled them, when Baxter said the wonderful words, *I love you, Miss Kubelik,* and Miss Kubelik didn't respond by looking at him or replying to his declaration of love, but said the final words that have become cinema history, *Shut up and deal,* I just couldn't hold back my tears. I lay awake for a long time and pictured myself tossing my key onto Höllinger's desk, knowing I could never bring myself to do it, could never give up everything and simply leave, with no idea where I would go.

The next morning I took an early train specially to listen to

the man in the underpass. He was still playing the same song and I stood and stared at him. Was that what my future was going to be like? I asked myself. Either end up playing tunes in the underpass, or carry on dancing to Höllinger's tune under the Whites. I tore myself away from the man with the accordion. No, I thought, I'll carry on, I'll toe the line, this very day I'll get two keys for Höllinger, then he'll cross me off the List and everything'll be all right. Full of determination, I strode off to the school. Just as I arrived Herr Krämer was coming up from the underground garage. I said, 'Six weeks and one day.' He took off his hat, nodded and asked me if I knew that Gräulich wore a toupet.

Since I was early, I went straight down to the media store; key C6 fitted the door. I switched on the light and looked for the cupboard where the videos were kept. It was open. I ran my finger along the rows of videos, but couldn't find the film I needed. Suddenly I heard a noise behind me and spun round in surprise. Holding my breath, I crept past the cupboards with the copies of ancient Roman statues and circumvented the obstacle course of projectors and stands. There was no one to be seen. Then I heard the slight shuffling noise again. It came from near the floor. I bent down. There was something under the white table against the wall. I heard a cough. I had a closer look. A tangle of blue, a sleeping bag from which a face slowly, cautiously, tentatively emerged, still half asleep and not noticing me: Heiner Stramm, the Media Resources Manager.

'My God!' I cried, 'what are you doing here?'

Stramm crept out of his hidey-hole. He'd slept there, he said, Stramm, Biology and Chemistry, Media Resources Manager. Kranich, English and German, I said. Since he stayed squatting on the floor, I knelt down. Why had he slept here? I asked. He. . . he. . . then suddenly it all burst out. He didn't know what to do, he said, putting his head in his hands, he couldn't stand it any longer, it was cruel, it was torture, he

couldn't explain it, he couldn't imagine how it had come about, he'd no idea what was going to happen now.

'Calm down, calm down,' I said, squatting on the floor. 'There's an answer for everything.' Out of the corner of my eye I had seen that his trousers had been hung over the back of a chair and there, in the middle of the blue seat cover, by itself, not attached to anything, in all its solitary glory, was Stramm's key, within reach, I only needed to stretch out my hand.

His wife had left him, Stramm said. Or, rather, she'd thrown him out. He'd been sleeping in the media store for the last three days. Again and again he'd gone down on his knees and begged her to let him into the house, but she'd remained adamant, there was nothing he'd been able to do about it.

Had they fallen out? I asked. No, said Stramm, that was the thing, there was no reason for her to behave like that, he'd always treated her right, given her everything she wanted, his conscience was clear.

'Herr Stramm,' I said, shifting a little closer to him, 'you can be open with me, mostly this kind of thing is, how shall a put it, a matter of sex, you know what I'm getting at?'

Yes, of course, said Stramm, but everything had been fine in that respect too, he'd hardly let a night pass without addressing himself to that aspect of their relationship. On the contrary, when he thought of all the effort, all the preparation he'd put into their nights – he'd left nothing to chance, he'd dutifully gone to her bedroom, he'd incorporated three, if not four changes of method into every act they'd performed. Mostly he'd used a song as lead-in and sat down beside his wife, but before it got boring he'd switch off the recorder and move on to a question-and-answer session to get her to understand her urges. Following on from that he'd often interpolated a classic skills practice section, but before that started to drag, he'd read passages from a relevant book to his wife in order to reinforce the mood that was developing. Nor had he ever forgotten to

include a silent-work phase, during which he observed his wife as she came to terms with her own feelings. Every groan, every term of endearment had been recorded as key points on the blackboard they had hanging above the bed instead of the usual mirror. Later on, when all the writing on the board had become a problem for his wife, he'd even gone over to projecting transparencies with suitable positions for the sex act onto the bedroom wall; moreover he had taken great care never to occupy his wife's attention for more than forty-five minutes.

At that moment the bell went. I got up, grasped Stramm's hand, pulled him up and said, 'Come on, get dressed, we're late already, tell me, have you seen the video of *The Grapes of Wrath* anywhere?'

'Yes,' said Stramm, 'Herr Safft borrowed it, yesterday, he said he needed it some time next week for his first-year course.' As I closed the door to the media store behind me, I heard Stramm's voice: 'My key, where's my key?' But I was already going up the stairs.

18

I went straight to Safft and asked about the film. It was at home, he said. Why? I cried. He was going to copy it, said Safft. I needed the film, I said, *immediately*. Now take it easy, said Safft, it couldn't be that important. When did he have a free period? I asked Safft. Not at all, he said, his full whack plus four extra hours. Was he married? I asked. Safft nodded. Then he should give me his number, I said. In the staff address list, Safft said, leaving the room as the second bell was already ringing.

I got through the first period. As I left the classroom I ran into Kniemann, who clutched my shoulder with her right hand and whispered in my ear that she needed some stuff, new stuff, did I have anything for her. I tore myself away, throwing her a few crumbs such as Troy, Hannibal, Hastings, and left her on the stairs, holding forth to herself. As I was going past the ground-floor windows I saw a green Mercedes saloon being parked in the playground, where cars were actually forbidden. Frau Klüting got out and stuck a huge cardboard sign with the letters C, A and R on the roof. Then Hilde Bräunle came running up and asked me if I knew anything about computers, the printer wasn't printing. 'No,' I said, and went into the staff room, where I was treated to the sight of several pupils following Achim Renner and carrying three statues of Greek gods, naked, three foot high and clearly very heavy. Renner directed the pupils to his desk. Finally I managed to get to the staff address list, opened it, found Safft's telephone number and, so as not to lose it, wrote it down on the back of my hand, at which point Pascal came up to me and said he couldn't believe it, it was simply incredible. What was? I asked. That morning he'd had a phone call from the canon, Pascal said, he, Pascal, had been nominated for the Golden

Rosary awarded annually to the best Religion teacher
appointed by the Church. Congratulations, I said, as the bell
rang, and left the staff room. When the next class was over and,
as per regulations, I had locked the door after the last pupil
had left and then watched Frau Klüting return her new
Mercedes to the car park, I went to the staff room and rang
Safft's number. The answerphone clicked in. I left a message
trying to explain the problem to Frau Safft as concisely as I
could and, giving her my own number, asked her to leave
the number of the film on my answerphone. Then I
replaced the receiver and was just about to sit down on the
sofa when suddenly, while the teachers, all unsuspecting,
were quite happily buzzing round their desks in the usual
hustle and bustle of the break, both doors burst open simul-
taneously and three, five, ten, fifteen men dressed in white
slipped in unobtrusively. Absolute silence. A silence which
was broken by a terrible word. 'Committee of enquiry,' said
one of the men. Yesterday, at four twenty-five p.m., he went
on, Education Head Office in Stuttgart had received an
anonymous phone call. According to paragraph 27/9 of
departmental regulation CIII *On the official use of telephones*,
anonymous phone calls were strictly forbidden. The
anonymous phone call had, however, made it crystal clear
that a mole was going about its nefarious business among
the staff of the ERG in Göppingen, an *unidentified* mole,
consequently unauthorised and therefore forbidden. Further
they had been informed that an illegal drawing of lots had
taken place during an official meeting, which fact repre-
sented a violation of departmental regulation A IV *On the
use of measures to produce a decision among recalcitrant staff*. As a
result of these regrettable incidents, a thorough investigation
had been ordered from above and would be carried out with
immediate effect. 'No one is to leave the room,' said the
spokesman.

The first item on the agenda was the identification of the

mole, he said after a while, holding a letter in his white-gloved hand. This letter, the spokesman said, had been sent, anonymously, to Frau Dr Margarete Wirtz, headmistress of the renowned KNOGY. The letter contained confidential information concerning the internal affairs of the ERG, consequently the writer of this letter, exhibit A, could only be a member of the ERG staff. There would be no problem identifying the miscreant, since the envelope and the paper on which the letter was written revealed the fingerprints not only of the headmistress, Frau Dr Wirtz, but also those of a second person. This second person would now be identified. Some of the Whites began to take the teachers' fingerprints, whilst others set up a kind of laboratory in the staff library, inserting the prints that were brought to them in machines and comparing them with the prints of the mole on the envelope.

After some time the door opened again and two Whites ushered Höllinger and Bassel into the staff room. The spokesman now addressed Höllinger directly. The second point on the agenda, he said, was the loss of authority, unacceptable to the system currently in force, of a headmaster who had flouted the regulations and betrayed the authority which was his prerogative by addressing a *plea* to the staff, thus for a brief moment descending to the level of the teachers under his tutelage. This dereliction of duty was compounded by proceeding to a decision by drawing lots. That was unauthorised, irregular, neither mentioned nor provided for in any regulation, an action on the part of the person with ultimate responsibility within the school indirectly tantamount to perverting the whole of the State education system as well as acquiescing in the possibility of a wrong decision. Höllinger stared at the White's leader, a broken man. The sentence, the Whites' leader continued, was a reduction of salary by three increments. Höllinger would, however, remain as head of the ERG, since the matter was a first offence.

Otherwise he had an unblemished record, as the data in his file revealed.

'No!' Kniemann suddenly cried out. No, she said, in loud and animated tones, she could not tolerate that, it was outrageous, it was another nail in the coffin of classical education, one could not simply say *dayta*, with a long a, that was not correct, she could not let that pass, *dare* was the only first-conjugation verb with a short a in the stem, consequently one should not say *dayta,* as if it had a y in it, the correct pronunciation was *datta,* you had to think of it as having a double t, *dare, do, dedi, dattum*, Kniemann said, she would expect an educated person to know that.

Höllinger squirmed and snarled at Kniemann, silently but with vigorous gestures, then turned back to the Whites' leader, who seemed somewhat confused by the unexpected interruption, and whispered, 'Thank you,' several times over before making an effort to recover his composure. Then the door to the library opened, one of the Whites emerged and handed his boss a slip of paper. 'The mole,' the spokesman said, after having glanced at the piece of paper, 'has just been identified.' He looked at the assembled staff, his expression indecipherable. His name was Jensen, first name Josef. It was out of the question that he should remain at the ERG, his sentence: salary downgraded to that of a teacher in his first post and transfer to Outer Swabia. Mechanically Jensen put his hand in his pocket, took his key off his key-ring and placed it on the table. Two of the Whites collected all his teaching materials while two others grasped Josef by either arm and led him out of the staff room. That was the last I saw of Josef Jensen.

19

Their task had not yet been completed, the Whites' leader went on. Since they were here, they might as well take the opportunity to check out a few of the other members of this apparently bolshie staff . Thirteen teachers, he said, had been selected at random for class inspection. He began to read out a list of names. Alphabetical. Each one whose name was passed over heaved a sigh of relief and slumped back in their chair. Ammel, Bruns, Kramny, Kranich. . . That was all I heard. From that point onwards it was as if I were in a trance. I saw one of the Whites come floating towards me, as if in slow motion, through an eerily shimmering veil of mist. I couldn't look him in the eye because he was wearing reflecting glasses. He took me by the arm, picked up my briefcase and escorted me out of the staff room. He asked no questions, he seemed to be *au fait* with everything and led me like a blind man through the school to the room where 5d were waiting for me. I was feeling dizzy, I could hardly stand as the White official sat down in the back row, spread out an assessment form and sat there, pen at the ready. All I managed was a hoarse croak. 'Good morning,' I said to the pupils, in German, since I couldn't for the life of me think what the English was. However, the pupils tried to help me, scribbling sentences and key words on pieces of paper, which at least allowed me to negotiate the first fifteen minutes without disaster. Once they were past I'd more or less recovered myself, I was breathing more easily, was beginning to see things again through the thick fog oozing out of my eyes. I could once more recognise the faces of individual pupils – and the White official as well. He was writing all the time. From then on I focused on him alone. If he scratched his ear, my heart missed a beat, if he frowned when I used a word, I immediately cried 'Wrong,' to the

class; if he then looked up from his notes in astonishment, I said, 'No, it's correct.' What was he writing down all the time? was the thought I couldn't get out of my mind, he was writing more than I was saying, more than the pupils were saying, he was writing enough to fill a book, no one could make the number of mistakes he was noting down, I thought, perhaps he was writing about other things, about my posture – I threw out my chest – my voice – I started to shout – my handwriting – I wrote every letter precisely on the board – I would have loved to go across to him and look over his shoulder, I'd have said, 'Oh yes, what I said there's definitely wrong, I knew it was wrong, I *deliberately* said it like that just to test out the pupils, to see if they noticed the wrong word.' Perhaps he's writing good things down, I suddenly thought, but then I thought, no, what's good about this lesson? I was close to collapse when I was saved by the bell, and the pupils too were wiping the sweat from their brows. I sat down, opened the class register, initialled it, wondering what topics had been dealt with in the class I'd just taken. I had no idea. I wrote: *Revision.*

Then the White official led me to an empty classroom and I took deep breaths as I sat down opposite him, casting expectant glances at the assessment forms he'd placed on his knees. He'd filled up ten sheets. I was prepared for the worst. He'll launch into me straight away, I thought, shout, criticise me, tell me I'm an incompetent, useless teacher, a complete failure, but nothing like that happened. He calmly read over what he'd written. For ten minutes, twenty minutes, half an hour – nothing. 'Well?' I asked. No response. Another ten minutes, twenty minutes, then he suddenly looked up. I froze. Slowly, as slowly as possible, he took off his glasses. I was looking into a pair of watery, glistening light blue eyes and the White official parted his lips, savouring every syllable as he said, 'STEPS – WILL – BE – TAK – EN.' Then he stood up, turned round and left me there in the classroom. I was

trembling and felt queasy. I decided to go off sick for the rest of the day, but gave up the idea at the thought of Bassel's substitute roster. I went to the staff room. It looked like a battlefield. Teachers were slumped all over the place, broken, finished, marked by the stress of the inspection. They were being cared for by those who had been spared the experience. I too was immediately attended to by Hilde Bräunle. She wrapped a blanket round me, sat me down on the sofa, handed me a cup of tea and rubbed my hands. I was overcome with gratitude. 'Frau Bräunle,' I said, the tears welling up, 'I will never forget this.' Chaos had broken out in the corridors, I was told. The teachers who had been inspected were no longer capable of teaching, the pupils, unsupervised, were leaving their classrooms.

In the general confusion I was the only one to hear a gentle knock on the staff-room door. I pushed myself up off the sofa, dragged myself to the door on wobbly legs and opened it. A first-year with a huge satchel was in the corridor. I went out. He'd found 'this here', he said, he was handing it in. I said nothing, just seized the key he was holding out to me in a convulsive grasp, put it in my pocket, where it clinked as it joined Stramm's key, and wiped my brow. I remembered the vow I had made that morning, remembered that I was determined to hand over *two* keys to Höllinger, that that would solve all my problems, that he would cross me off the List and that in future I would count myself among Höllinger's supporters. Now I had the two keys. But at that moment I suddenly felt faint again, my knees threatened to give way, I staggered back into the staff room and flopped onto the sofa, closed my eyes and thought, I've got the keys, I'm safe now, I don't have to hand them in today, I can do it tomorrow, I want to be at my best when I face Höllinger, tomorrow, I thought, I'll do it tomorrow, he'll cross me off the List tomorrow.

Kniemann was sitting beside me. Typical she said, she'd

never been inspected, they seemed to be afraid of her and her knowledge, even the Whites. I handed her the sheet of paper with my questions and for the next fifteen minutes Kniemann went on at me in a quiet whisper and I pretended I was listening.

20

Back at home the first thing I did was to check the answer-phone. I had three messages. The first was from my mother. How was I getting on, how was school, what were my colleagues like, what was the headmaster – I pressed 'delete'. The second message was from the head. It had come to his notice, he said, that on that day I had acquired two keys but had not handed them over to him, Höllinger. That was a breach of the trust he had placed in me and a dereliction of my duty as SSO. There would be repercussions. Tomorrow, his office, during break. The third message was from Frau Safft. She had the cassette in her hand, she could see the number clearly. She couldn't imagine why on earth I needed to know the number, but since on the telephone I had given the impression that the matter was not without importance, she would pass it on to me. The number was. . . My answerphone ran out of tape. I sat down on the carpet beside the telephone and took out a cigarette. Checking the number on the back of my hand, I dialled. Once more I got the answerphone. I asked Herr and Frau Safft if they would be kind enough to phone through with the number again.

I spent the rest of the day preparing classes, but I could tell my mind wasn't really on it. I finished at midnight, ate something and then sat in my chair listlessly. I had the briefcase in my lap and was holding it tight. I was meditating. I chose a form of meditation I had developed on teacher training during the grading meetings for the first and second years when the grades for general behaviour and effort were read out; according to regulations, they were obliged to read out every single behaviour and effort grade of every single pupil. Sitting there on the floor, I was silently humming the calming tune, while in my mind's eye I could see the weary nods of the

teachers round the table. There was a particular aura of quiet ritual about them as they heard that Caroline had always done her work to the complete satisfaction of her teachers, she was a lively participant in class discussion, was always attentive, had always performed set tasks carefully and punctually, was able to follow the full range of the material covered and was popular with her classmates; Frank did not always do his work to the complete satisfaction of his teachers, was an occasional participant in class discussion, was sometimes inattentive, usually performed set tasks carefully and punctually, could almost always follow the full range of material covered and was moderately popular with his classmates; Pia had not done her work to the satisfaction of her teachers, she never participated in class discussion, was often inattentive, performed her set tasks neither carefully nor punctually, could not follow the full range of material covered at all and was extremely popular with all her classmates, career prognosis: hairdressing apprenticeship.

The telephone. I opened my eyes and blinked. I was sitting in my rocking chair. It was light outside. Eight o'clock in the morning. The exertions of the last few days had been too much for me. What day was it? Friday? I couldn't move, couldn't even stretch out my hand to pick up the receiver, so that I heard my own instructions about leaving a message and then Frau Safft's voice telling me they had got back very late the previous evening and hadn't wanted to disturb me. The number was 5387. All the best. I listened for the bleep as the answerphone switched off then opened the briefcase. In it was a forged passport with a photo of me under the name of Erwin Röder together with school-leaving, degree and teacher training certificates, a letter of appointment as a fully qualified teacher, a tenancy agreement plus a key to the apartment and a street map of Frankfurt with the location clearly marked, an account with €10,000 at the Deutsche Bank, which money, an accompanying letter said, would be

released at 1 p.m. on Monday on condition I had presented myself beforehand at the HDGG in Frankfurt at eight o'clock, if I had decided to take up a post in Hessen, with the Reds. There was also a fat padded envelope on which was written: *Perhaps needed to assist your escape from Baden-Württemberg*. In the envelope I found a gun, ammunition and instructions for use. I read the instructions, loaded the gun, stuck it in my waistband, pulled my shirt down over it, made a fire in the bath to burn my old passport and everything else that linked me to my former identity, grabbed a suitcase, packed the new documents, a few articles of clothing and things that seemed important to me, walked, slowly, unhurriedly, to the station, got on the train to Göppingen, found, as I put my ticket in my jacket pocket, the adverts for flats I'd torn out of the Göppingen newspaper, screwed them up, threw them away and heaved a sigh of relief. In Göppingen I put the suitcase in a locker and set off. 'Six weeks and no days,' said Herr Krämer as I arrived.

I nodded agreement. 'No days.'

I arrived just at the right time. Five minutes before the break. I went over to Pascal, who had a free period, and wished him the best of luck for the Golden Rosary; Achim Renner I had to cheer up because the previous day a pupil had accidentally dropped one of the statues. Most of the others, including Kniemann, Klüting and Linnemann, were teaching. I told Renner to give my best wishes to all those I knew.

'Why?' he asked, 'What's up?'

At that moment the bell went. I asked Renner a question of my own: why didn't he simply chuck it all in, the school and everything?

'And then?' he asked with a blank look. 'Where could I go then?'

'To Bali,' I said, going to the staff-room door.

The teachers poured in. When, after five minutes, everyone

was there, apart from those who had playground supervision, I took out one of the keys I'd got hold of the previous day, cleared my throat and called out, 'I've found a key.' Silence. Then scattered cries, 'A key!' people exclaimed, 'found and not handed over to the head, bravo Kranich!' I put my hand in my pocket, took out the second key and said, 'I've found another key.' Now the teachers were crowding round me, 'Good old Kranich,' they cried, Stramm and Klüting were moved as they took back their keys, thanking me over and over again, the other teachers smiled and waved at me. Then I took the envelope the head had given me out of my pocket and shouted, 'I'm one of the two Secret Security Officers.'

'Rubbish,' cried Klüting, the first to recover her composure. 'If that were true then you wouldn't have given us our keys just now.'

'That's right,' some other teachers cried out.

I handed Klüting the envelope. 'There's the proof,' I cried. Klüting opened the envelope.

'Why should there be two?' Linnemann shouted. 'There's never been two SSOs before. I'm firmly convinced – '

'It is true, it is true,' Klüting cried out in horror, 'he is one.'

The teachers all shrank back. Still standing by the door, I took the gun out of my waistband, slid the magazine in and out, as I'd read in the instructions, aimed at the ceiling and pulled the trigger. A bang, smoke, plaster trickling down from the ceiling. 'It's a hold-up,' I said. The teachers were silent.

'Gräulich, I said, get your hat and collect all the school keys.' Gräulich took his hat from the hat stand and went round the teachers; most of them had problems getting their keys off the locks and chains with which they were attached to their belt buckles. It took ten minutes before Gräulich brought me a hat packed with school keys. By this time those who had had playground supervision had returned and I'd taken care of them. I took the hat from Gräulich, said, 'No

one's to move,' took aim, shot at the telephone, left the staff room, closing both doors behind me, stuck the gun back in my waistband and went to the school office.

Bassel, clearly in a good mood, was leaning on the counter and greeted me, saying, 'Hey, Kranich, there's someone shooting again, are the second-year probationers practising for their crit lessons already?'

I drew the gun and said, 'Not as far as I know.'

After I'd removed Bassel's and the secretaries' keys and locked the three of them in Bassel's room, I paused for a moment in the office. My heart was beating faster. Now, today, on my fifth day at the school, for the first and only time I would enter the headmaster's office without knocking.

'What do you want?' asked Höllinger, looking up from his desk. He couldn't see the gun, which I had stuck in my belt.

'I've done what you asked, Höllinger,' I said.

'What do you mean?' Höllinger asked, looking up from his desk.

'Keys,' I said.

'You've got a key?' Höllinger asked. 'Wow, Kranich, well done, whose is it?'

'Everyone's,' I said, turning Gräulich's hat upside down and letting sixty rust-coloured school keys clatter onto his desk. The expression on Höllinger's face exceeded all my expectations.

'Everyone's?' The word had to squeeze out between his teeth. 'What do you mean by that, Kranich?'

'Everyone's,' I said. The headmaster said nothing.

Then I said, 'No, Höllinger, not everyone's, there's still one missing.' I took my own key out of my pocket, shut my eyes for a moment and saw Jack Lemmon toss his key on his boss's desk, a look of revulsion on his face, that was just how I wanted to look, that was just the way I wanted to throw the key, with the same expression, the same posture, the same flick of the wrist, and already the key was flying through the air

straight at the desk and landing with a clunk on the pile of all the other keys.

Höllinger looked at me. 'Yours, Kranich?' he asked, 'yours?'

I nodded. 'You're resigning?' I nodded again, already cele-brating my victory inwardly. Then Höllinger stood up, held out his hand and said, if that was the case, he wished me all the best for my future career. Eyes wide, I held out my right hand while with his left Höllinger fished a bottle of champagne out of the cupboard behind him and said, 'We must drink to that, mustn't we, Kranich?' I tore myself away, ran out of the door and flew down the stairs. The last thing I heard as I left the school was a bang.

EPILOGUE

Just get away from Johnstrasse, I thought, just get through this thicket of exhaust fumes, just get past the petrol station, the smell of oil, the mirror windows of the bank, just leave all that behind you. The traffic light, on red for minutes, then briefly green. Finally the bridge, the underpass, the accordion player. I ran past him to the lockers, took out my suitcase, got on the train to Frankfurt, found the smoking compartment, lit up, stretched out my legs, oblivious to the passing landscape, and got out in Frankfurt. As I was rummaging round in my suitcase for the street map, a man came up to me, dressed in red. 'Follow me,' he said. I followed him. Outside the station a car was parked. I got in the back. Beside me was another man in a suit, he scrutinised me but said nothing. The car started and the man looked out of the window.

'Where are we going?' I asked him.

'To your flat,' he said.

'To my flat?' I asked.

'To your flat,' the man said.

For while we said nothing.

'And this flat,' I asked him, 'where is it?'

'Right next to the school playground,' he said.

'And *you*,' I asked, 'who are *you*?'

'I am the man who will write your appraisal.'

Dedalus Celebrates 25 Years

Dedalus celebrates its twenty-fifth year as a publisher in 2008. The tributes and congratulations have been led by Arts Council England.

Here are a few of them:

"Dedalus is to be warmly congratulated on its critical success in the field of literary publishing and translation. For the past quarter of a century Dedalus has built up its strong reputation within this specialised sector, and to the point where it can now celebrate its quarter century of publishing and partnerships with confidence and just pride. The word 'congratulations' should be translated into every language under the sun and put on every page of this catalogue."

> *Sir Christopher Frayling, Chairman Arts Council England*

"As a publishing house committed to printing work of the highest quality, Dedalus is a national treasure amid a sea of mediocrity. Dedalus earns our gratitude and deserves our encouragement and support."

> *Stephen Calloway, Victoria & Albert Museum*

"One of the most creative publishers on the British independent scene, Dedalus has been publishing excellent French translations for the last 25 years. From Jacques Cazotte to Barbey d'Aurevilly, Huysmans and Sylvie Germain, Dedalus has helped make the great names of French literature accessible to British readers. A remarkable achievement."

> *Paul Fournel, Head of the French Book Office in London*

"I would like to express my appreciation for the excellent work Dedalus has carried out publishing Portuguese translations. During the past 25 years, Dedalus has, enthusiastically

made classic Portuguese literature available to many British readers. Eça de Queiróz and Mário de Sá Carneiro, two great Portuguese writers have, among other authors, had their work translated by Dedalus."

António Santana Carlos Ambassador of Portugal

"Excellence, innovation and especially courage sum up Dedalus perfectly. To have stayed the course for 25 years is no small achievement in the world of independent publishing - or publishing generally, with its corporate mergers. Dedalus also makes it fun. Here's to another 25 years of Dedalus Decadence - and to continuing Arts Council support."

Gary Pulsifer from Arcadia Books

"Dedalus have for many years been leading players in the industry in sourcing classic literature in its original language and making new translations available to an English-reading public. The Calouste Gulbenkian Foundation in the UK have been delighted to partner Dedalus in the translation of, among other works, major novels by Eça de Queiróz, considered to be one of Portugal's greatest writers. This has been a valuable strand of our work in helping bring changes to the experiences people can enjoy in life through our support for education, the arts, and other social change alongside our specific remit to promote Portuguese culture in the UK and Ireland."

Andrew Barnett Director Calouste Gulbenkian Foundation (UK)

What the critics say about Dedalus

Our books have been highly praised by literary critics and writers over the last twenty-five years. Here is a sample of what they have said.

"Dedalus should be treasured: a small independent publisher that regularly produces works of European genius at which the behemoths wouldn't sniff. If the corporations did care to look at this new work, they would find, on the surface, a precursor to W. G. Sebald, a Symbolist vision of the city that lays the way for Aragon and Joyce, and a macabre story of obsessive love and transfiguring horror that is midway between Robert Browning and Tod Browning. This is a little masterpiece, from a brave publisher. If only Scotland could boast the same"
S. B. Kelly in Scotland on Sunday

"the premier publisher of decadent, turn-of-the-last-century European fiction."
Michael Dirda, (Literary Editor) in The Washington Post

"This is one of the best anthologies - as an anthology - I have ever read. It now has 43 tales in it, all of them exciting, all beautifully translated, ranging from the Austro-Hungarian decadence to modern science fiction. It also has an excellent introduction, describing the particular qualities of Austrian - as opposed to German, or any other - literatures. The Austrians, according to Mitchell, have complementary passions for detail and for the dissolution of boundaries - between the real and the unreal, between dream and waking, between life and death. One of Mitchell's great achievements is the juxtaposition of a string of tales in which people hover between life and death, in a kind of animated limbo,

constructed with a love of detail rather than a desire to create
vague horror."

A. S. Byatt on The Dedalus Book of Austrian Fantasy,
The Guardian Book of the Week

"James Joyce in *Finnegan's Wake* described a character as
'absintheminded', while lesser punsters spoke of absinthe
making 'the tart grow fonder'. It reaches across time, this
'potent concoction of eccentricity and beauty'. Alluring, then
informative and witty."

Brian Case, Time Out One of 50 reviews for
The Dedalus Book of Absinthe

"I was not expecting to be very interested in a first novel
about professional cycling. In fact I was entranced, educated
and entertained by a rich comic stew containing love, sex,
speed, power and drugs."

Peter Buckman in The Sunday Telegraph on
Bad to the Bone

"Congratulations to Dedalus Books, the Cambridgeshire-
based maverick outfit whose list of weirdly wonderful global
literature scooped two of the prizes. David Connolly picked
up the for the year's best translation from Greek for his
anthology of fantasy and Oliver Ready the Rossica Inter-
national Prize for Russian for his version of Yuri Buida's
novel, *The Prussian Bride*."

Boyd Tonkin in The Independent

"Robert Irwin is indeed particularly brilliant. He takes the
story-within-a-story technique of the Arab storyteller a
stage further, so that a tangle of dreams and imaginings
becomes part of the narrative fabric. The prose is discrimin-

ating and, beauty of all beauties, the book is constantly entertaining."

> *Hilary Bailey in The Guardian on*
> *The Arabian Nightmare*

"Robert Irwin writes beautifully and is dauntingly clever but the stunning thing about him is his originality. Robert Irwin's work, while rendered in the strictest, simplest and most elegant prose, defies definition. It is also magical, bizarre and frightening."

> *Ruth Rendell*

"A veteran translator of Saramago and Pessoa, Jull Costa delivers Queiróz's 1888 masterpiece in a beautiful English version that will become the standard. The novel crystallizes the larger unreality of an incestuous society, one that drifts, even the elite heatedly acknowledge, into decline. This novel stands with the great achievements of fiction."

> *Publishers Weekly* stared review*

"This is part of a new series from Dedalus, the publisher of odd stuff, called Euro Shorts, which the publisher defines as 'short European fiction which can be read from cover to cover on Euro star or on a short flight.' Well, if you are going to start with *Lobster*, you are going to have an interesting journey. . . . There was a Lobster-shaped hole in world literature which has now been filled by this remarkable work."

> *Nicholas Lezard's, Paperback of the Week in*
> *The Guardian*

"*The Book of Nights* is a masterpiece. Germain is endowed with extraordinary narrative and descriptive abilities . . . She excels in portraits of emotional intensity and the gritty realism of raw emotions gives the novel its unique power."

> *Ziauddin Sardar in The Independent*

"A murdered woman, lying buried in the forests of the Morvan, is the still beating heart of *Days of Anger*. A rich, eventful saga of blood, angels, obsession and revenge, this marvellous novel is a compulsive, magical read, passionate and spell binding."

James Friel in Time Out

"There is little that can be said that would do justice to the controlled brilliance of Sylvie Germain's writings - *Night of Amber* is a fantastic book, a wildly inventive novel about childhood, death, war and much else. It creates a rich fantasy world, yet it is also very moving, and deals with the emotions of grief and love with an understanding and insight which few writers can match."

Edward Platt in The Sunday Times

"Dedalus have been steadily printing the novels of the astonishing 19th-century French novelist Joris-Karl Huysmans and as a bonus have reissued Robert Baldick's classic biography, one of the most elegant, stimulating and moving of all literary biographies, right up there with Leon Edel's *James* and George Painter's *Proust*, revised and annotated by Brendan King. The life and the work are equally compelling."

Simon Callow in The Guardian's Summer Reading

"Sun Piao is a superb creation - a flawed but heroic man dedicated beyond the call of duty to the rule of law in a society run by corrupt and amoral bureaucrats. The stifling control exercised by a totalitarian system pervades the book, adding emphasis to the tiny, fleeting areas of personal freedom that mavericks such as Sun manage to carve out. *Citizen One* combines cracking entertainment with a pinsharp analysis of the pressures building at the faultlines of Chinese society as the old guard of the communist system are challenged by a new generation eager for change and greedy for power."

Peter Whittaker in Tribune

Prizes

The excellence of our list has been recognised by the prizes we have won and been shortlisted for:

The French Translation Prize 1992 for Christine Donougher – *Book of Nights* by Sylvie Germain

The German Translation Prize 1998 for Mike Mitchell – *Letters Back to Ancient China* by Herbert Rosendorfer

Mike Mitchell was also shortlisted on two other occasions for the German Translation Prize for *The Golem* by Gustav Meyrink and *Stephanie* by Herbert Rosendorfer

The Russian Translation Prize 2006 for Oliver Ready – *Prussian Bride* by Yuri Buida

The Greek Translation Prize 2006 for David Connolly – *The Dedalus Book of Greek Fantasy* edited by David Connolly.

The Saltire Best First Book Prize 1995 for *Music, in a Foreign Language* by Andrew Crumey

The European Crime & Mystery Award 2003 for *Dragon's Eye* by Andy Oakes

We had two books on the Booker Prize longlist in 1995 *Exquisite Corpse* by Robert Irwin and *Memoirs of a Gnostic Dwarf* by David Madsen.

The Occult Book of the Year in 1992 for Mike Mitchell's translation of *The Angel of the West Window* by Gustav Meyrink

We have been shortlisted on three occasions for the Oxford Weidenfeld Translation Prize: Christine Donougher in 1996 for *Night of Amber*; Sylvie Germain, Mike Mitchell in 1999 for *Simplicissimus* by Johann Grimmelshausen and in 2000 for *The Other Side* by Alfred Kubin

We were shortlisted in 1995 for the Portuguese Translation Prize for Margaret Jull Costa's translation of *The Relic* by Eca de Queiroz.

Dedalus's Mission

It has been Dedalus's mission during the last twenty-five years to put British publishing at the heart of Europe. We would like to thank the cultural organisations which have given us a helping hand along the way.

The Austrian Ministry of Culture (Bundeskanzleramt)
The Calouste Gulbenkian Foundation
The Camoes Institute
The Danish Ministry of Culture
The Dutch Translation Fund
The Estonian Translation Fund
The European Union
Fili (The Finnish Arts Organisation)
The Finnish Embassy in London
The Flemish Translation Fund
The French Community of Belgium
The French Ministry of Culture
The French Ministry of Foreign Affairs, Burgess Programme
The M. B. Grabowski Fund
The Greek Ministry of Culture
The German Ministry of Culture (Inter Nationes)
The Hellenic Foundation
The Portuguese Book Institute
The Spanish Ministry of Culture

Dedalus Euro Shorts

Dedalus Euro Shorts is a new series. Short European fiction which can be read cover to cover on Euro Star or on a short flight.

Titles include:

Helena - Ayesta £6.99
An Afternoon with Rock Hudson – Deambrosis £6.99
Alice, the Sausage – Jabes £6.99
Lobster – Lecasble £6.99
The Staff Room – Orths £6.99
On the Run – Prinz £6.99

These can be bought from your local bookshop or online from amazon.co.uk or direct from Dedalus, either online or by post. Please write to **Cash Sales, Dedalus Limited, 24–26, St Judith's Lane, Sawtry, Cambs, PE28 5XE**. For further details of the Dedalus list please go to our website www.dedalusbooks.com or write to us for a catalogue.